Indian Tribes
OF THE NORTHWEST

REG ASHWELL
DAVID HANCOCK

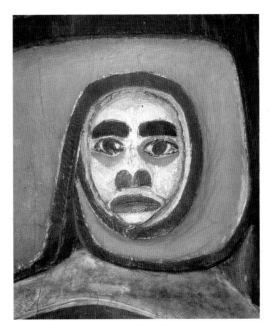

hancock

house

ISBN 0-88839-619-8
EAN 9780888396198
Copyright © 2006 David Hancock

Cataloging in Publication Data

Ashwell, Reg, 1921–
 Indian tribes of the Northwest / Reg Ashwell ; illustrator,
J. M. Thornton.

 ISBN 0-88839-619-8

 1. Indians of North America—Northwest Coast of North
America. 2. Indians of North America—British Columbia. I.
Title.

E78.N78A84 2006 971.1004'97 C2005-906696-2

Printed in Indonesia—TK Printing

Editor: Theresa Laviolette
Photo reseacher/writer: Venetia Inglis
Image editor: Laura Michaels
Production: Mia Hancock
Cover design: Rick Groenheyde, Mia Hancock
Photography: David Hancock unless otherwise credited.

Title page image: New 'Ksan Haida image

Published simultaneously in Canada and the United States by

HANCOCK HOUSE PUBLISHERS LTD.
19313 Zero Avenue, Surrey, B.C. Canada V3S 9R9
(604) 538-1114 Fax (604) 538-2262

HANCOCK HOUSE PUBLISHERS
1431 Harrison Avenue, Blaine, WA U.S.A. 98230-5005
(604) 538-1114 Fax (604) 538-2262

Website: **www.hancockhouse.com**
Email: **sales@hancockhouse.com**

Contents

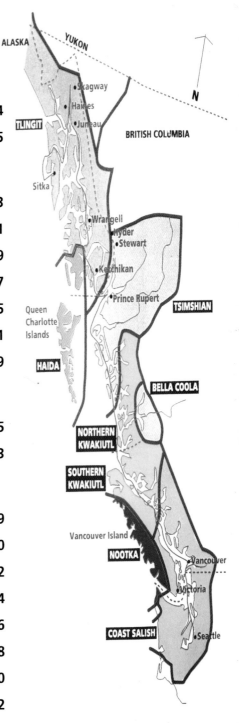

Reg Ashwell

Foreword

Author Reg Ashwell was greatly helped in the preparation of this booklet by notes he made over the years after long conversations with such venerable Natives as the late Chief August Jack Khatsahlano and Ellen Neel, among many others. August was the last of forty great medicine men of the ancient Order of Dancers of the Squamish Indians. Ellen was a noble of the Nimpkish band of the Kwakiutl Indians of Alert Bay and the granddaughter of the well-known carver, Charlie James. Ellen was destined to become almost as famous as her grandfather, and her carved and painted totem poles of yellow cedar are now in museums and private collections all over the world.

Mr. Ashwell was also privileged to enjoy a firm friendship with the late Mildred Valley Thornton, internationally recognized painter of Indian portraiture and author of *Potlatch People*. It was she who, besides imparting much of her own knowledge and wisdom concerning Native art and lore, introduced him to many of the Indians who subsequently became his friends.

Reg Ashwell worked as a freelance writer and his articles on British Columbia Indians, most particularly on Northwest Coast Indian art, have been published in many leading British Columbia newspapers and magazines. He was born at Prince Rupert, British Columbia, on July 12, 1921, and was raised near Terrace in the land of the Tsimshian.

The Indian Tribes

D'sonoqua mask, Kwakiutl
Campbell River gift shop.

The origins of the native inhabitants of the Pacific Northwest, from Oregon to Alaska, have never been fully established. It is believed they migrated from Asia via Siberia, (between fifteen and thirty thousand years ago,) over a narrow isthmus of land, which in later times became submerged beneath the waters of the Bering Straits. There may well have been successive waves of migrants who gradually dispersed themselves all over the North and South American continents.

Whatever their beginnings, by the time the first European sailing ships were sighted in our coastal waters, the great Northwest was already settled by diverse people, speaking many different languages and dialects, and with rich cultures of their own. Essentially children of nature, they enjoyed an almost mystical affinity with her forces. Indeed, they saw humans and nature as one, and this belief profoundly affected their attitude to life. Children were taught never to interfere with, or molest, any living creature. A very old totem pole, which stood for many years at the ancient Haida village of Tanu, graphically illustrates this fact. It was known as the "Weeping Totem Pole of Tanu" and the strange legend surrounding it was told around the lodge fires long before the arrival of the Europeans.

It all happened on a tragic day long ago, when Chief Always Laughs ruled the people of the northern island of the Queen Charlotte group. Always Laughs was a wise man who knew that the Great Spirit would not deal kindly with people who molested or hurt any creature having life. People could kill for food, but not for pleasure.

One day the chief led a hunting party, including seven sons, two grandsons, and seven canoe loads of people to the isle of Tanu to hunt for deer. The hunting party split into small groups and went off to hunt, leaving the two grandsons to guard the fire which had been laboriously lit by rubbing together sticks and tinder against a pile of driftwood gathered for the purpose.

When the hunting party returned they found the fire out. The frightened boys explained that while they were gathering more drift-wood they found a large frog and threw it on the fire. It swelled to very large proportions and then burst with a loud bang. After that, the boys gathered all the frogs they could find, both large and small, and threw them on the fire to hear them burst. "But the last frog was the largest," recalled the younger of the boys. "When he burst, he put out the fire!"

The chief and his party were horrified. At first they merely lectured the boys telling them that those who harm the Great Spirit's creatures will surely suffer a similar fate. Finally, overcome by a great foreboding, and urged on by the grieving old chief, the whole party made a dash for their canoes. Not even the fat deer of Tanu could interest them now.

But it was too late. As they ran to the shore the earth began to tremble and roar. The ground opened beneath them and the hunting party disappeared. The only person to survive was the old chief, and when he arrived home he became known as "the chief who always weeps for his children."

In memory of the chief the remaining relations and tribe erected a totem pole carved from a large cedar tree. It depicts the chief, wearing his conical ceremonial hat, weeping two very long tears each of which terminates on the head of a grandson. On the chief's breast sits a large frog. The pole was carved with great imagination and power, and became famous among the Haida, where it was known as the Weeping Chief Totem of Tanu. However, the true origin of the Weeping Pole of Tanu is lost in time, and there are several conflicting legends surrounding the pole.

Famed anthropologist Dr. Marius Barbeau (1883-1969) wrote that the pole was still standing in the bush when he visited Tanu in 1947. The main portion of the pole, featuring the Weeping Chief, was eventually removed to the Royal BC Museum. Francis Poole, the English civil and mining engineer who spent two years among the Haida in the 1860s, complained in his book "Queen Charlotte Islands" about a Haida chief stopping him at his favorite sport of taking pot shots at seals and crows, and ordering him never to do it again.

According to early Indian belief, all living creatures shared in a world of mutual harmony and understanding. The main difference between them was in their external appearance. Strip a bird of his

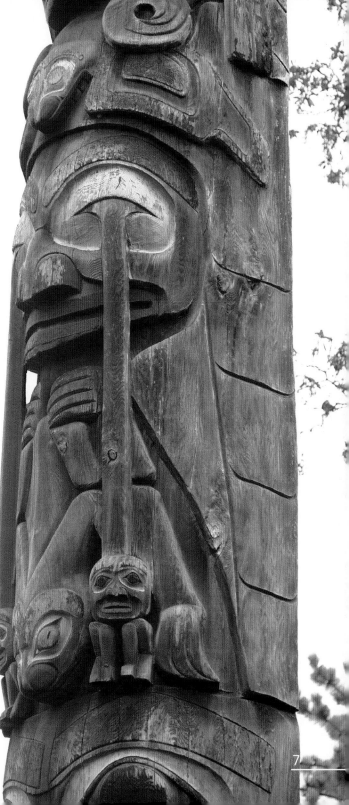

Weeping Chief Totem of Tanu.

feathers, or the fur from a bear, or the scales from a fish, and the form was indistinguishable from human form. To interfere in any way with the environmental dwellings of the salmon people, or the bear people, would be unthinkable and would surely bring swift retribution from the spirits of the creatures involved. This oneness of life" philosophy also led to the concept of "animal-people" — beings with the characteristics of both.

Instead of great bustling cities of steel and concrete there were only isolated Indian villages scattered along the shorelines and riverbanks. There were no roads, only a few Indian trails skirting the waterways and rarely penetrating far into the great pathless forests of cedar, fir, spruce, hemlock and pine. Transportation was by canoe or on foot, since in those days the Indians had no horses. In some areas there were vast marshlands, inhabited by many varieties of waterfowl and cranes.

Today most of these marshlands no longer exist. They have been drained off to make room for farmland, housing developments, and highways. An example of this is the great Sumas Lake basin. Before the days of the early settlers, great portions of the central Fraser River Valley were under a shimmering expanse of shallow water.

Picture then, a beautiful, yet lonely and silent land as it must have been in the days when the great forests were still intact, when the waters literally teemed with fish, and when the skies were sometimes black with myriad migrating birds. Vigorous and extremely creative people — the Indians of the Northwest Coast — occupied the coastal regions, from Alaska down through British Columbia and into the States of Washington and Oregon. The coastal Indians of British Columbia were divided into seven linguistic groups, speaking totally different languages and dialects, and yet enjoying a similar culture and life style.

Further inland, where the mild coastal winter rains gave way to snow and bitter cold, life for the two Plateau tribes in the Interior and southeast, and the seven Athapaskan tribes in the north, was necessarily of a harsher nature. These tribes were forced into a nomadic or semi-nomadic existence, resulting in less complex social organizations. They were, nonetheless, virile and energetic people and were as creatively and artistically inclined as their cousins on the Northwest Coast.

Old Haida totem poles, Queen Charlotte Islands.

9

The Prairie Indians were subject to much colder weather and utilized more animal skins for clothing. With colorful headdresses of eagle feathers, leggings, moccasins and tunics of deerskin, they remain the stereotypical image of the noble Aboriginal of long ago. But the fact is that the coastal tribes didn't wear feathered headdresses, leggings, or moccasins; in fine weather the men preferred to go around totally naked. Yet never were a people so imbued with love of decoration and design. Indeed, when clothing was worn it was usually for decorative effect, or as a slight protection against rain.

The usual form of headgear was in the shape of a truncated cone with a wide, flared base. These hats, made from spruce roots or cedar fibers, were often exquisitely woven works of art, beautifully painted with bird or animal designs, cleverly adapted to the shape of the hat.

For ceremonial occasions, chiefs and nobles of the tribe who could afford them wore carved and painted wooden helmets or headdresses, sometimes intricately inlaid with abalone shell and with white fur pelts fastened to the sides and back, giving a grand effect as they hung in snowy splendor around the shoulders of the wearer.

Nootka woman in traditional cedar attire.

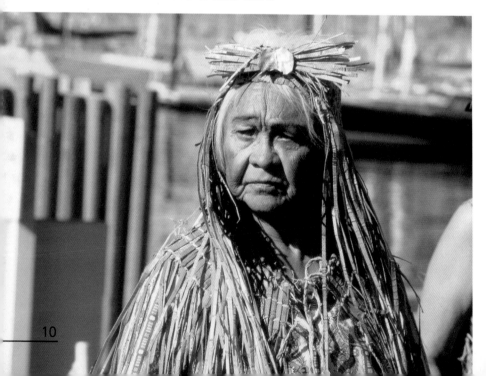

West Coast Native with speared octopus.

Interior of a Tlingit longhouse showing a medicine man performing a shamanistic ritual. (From an early engraving by W. B. Styles)

Tlingit

The Tlingit was the most northern tribe, and occupied the entire coastline of southeastern Alaska, from Mount St. Elias to the Portland canal, with the exception of the Prince of Wales Island that had been colonized by the Kaigani Haida shortly before the arrival of the Eurasian voyagers.

In such rugged and mountainous regions communication was almost entirely by sea. The Tlingit made fine, well-balanced dugout canoes from red cedar, and made long voyages to trade their sea otter skins, copper from the Copper River, and hand woven blankets, in exchange for the shell ornaments and slaves which came up from the South.

Their villages were built close to the water facing the shoreline. They constructed large gabled plank houses, elaborately carved and decorated with painted designs. The interiors were spacious and comfortable, with the furniture consisting of a number of cedar

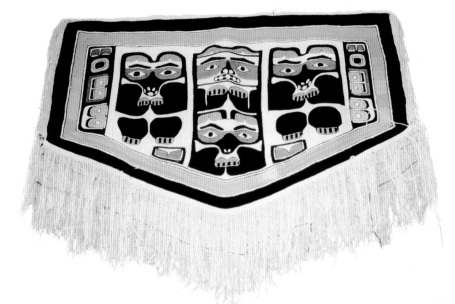

Tlingit Chilkat blanket, Haines Museum, Alaska.

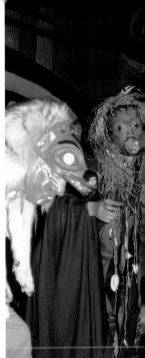

(left) Tlingit daggers, or "slave killers", were two of the most well known weapons on the North West Coast. Although slaves were treated well for the most part, they were killed on occasion. Knife blades were traditionally made of bone, stone, copper or iron. Hide string was used to attach the often elaborately carved handle. The dagger to the left, is a carved human face. It is inset with abalone.
Left dagger — Jilek
Right dagger — Juneau Museum, Alaska.

(right) Masks, costumes, and dance performed by Tresham Gregg with a dance and storytelling group from Haines, Alaska.

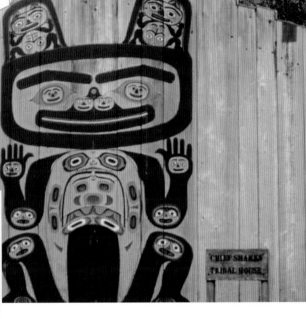

"Supernatural Grizzly" is painted on Tlingit Chief Shake's restored house, Wrangle, Alaska.

CHIEF SHAKES TRIBAL HOUSE

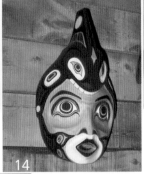

(left) Killer whale shaman mask by Tresham Gregg, Haines, Alaska.

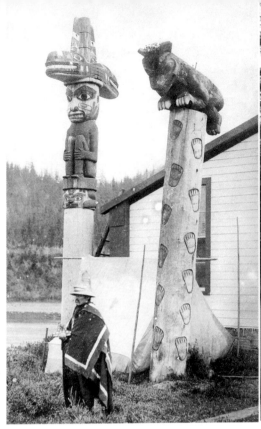

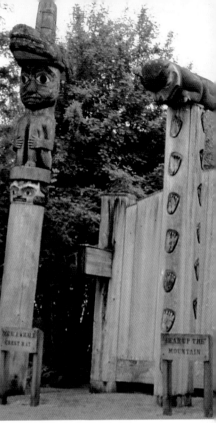

(above) An old photograph of Chief Shakes by his house. (Photo: Canadian Museum of Civilization)

(above) Chief Shakes house today. The "Killer Whale" pole and the "Grizzly" pole have both been restored.

(right) A masked Tlingit dancer wearing a button blanket and a Chilkat dance apron, Haines Heritage Museum.

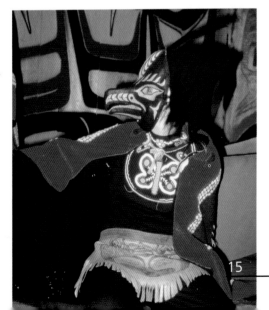

15

chests and boxes, some of them exquisitely carved and painted. These were used for storing food and clothing, masks, rattles and other paraphernalia used in ceremonial dances. There were raised platforms for sitting and sleeping, and these were strewn with skins and cedar bark mats. Placed on shelves beneath the rafters, or stored away in convenient recesses was a miscellaneous assortment of cooking utensils, baskets, horn spoons and ladles, carved wooden bowls, and other articles used in their daily lives.

Like all the Native tribes of coastal British Columbia, the Tlingit were wealthy. Wealth to them, of course, was the abundance provided by nature. The great forests of red cedar gave them their houses, canoes, totem poles, and storage boxes, to name but a few of the uses they had for these tall, straight and mighty trees. The sea literally teemed with salmon (their staple diet), and with halibut, porpoises, seals, and sea otters. Close to the shorelines were the great clam beds and an abundance of seaweed. Countless roots and berries supplemented their diet still further.

During the summer months the Tlingit devoted most of their time to hunting, fishing, and taking long journeys in their canoes to trade, and war with other tribes. In the winter the men were kept busy doing carpentry work of all kinds, and the women made baskets or wove blankets.

The Tlingit people, along with other Northwest Coast tribes, are renowned the world over for their achievements in the plastic arts, and in basketry. The old Tlingit baskets, made from very fine, closely woven, twined spruce root and decorated with strands of maidenhair fern and grasses dyed in natural color, have become very valuable and much coveted by collectors in many parts of the world.

But it was the beautiful Chilkat blankets, made from the inner bark of the cedar and mountain goat wool, and woven by the women from a design drawn by a male artist on a pattern board, which carried the art of the Tlingit to its highest development. Three colors were used. Black was obtained from hemlock bark; yellow from tree moss, and a greenish blue was obtained by allowing copper to corrode in urine, and then boiling the wool in the resulting liquid. The highly stylized designs on these blankets, with their intricate patterns and human and animal faces, are very pleasing to the eye.

The Tsimshian are usually credited with the early development of the Chilkat blanket, but it was the Tlingit who made them in large

numbers. The collection and preparation of materials, and the subsequent weaving of these fabulous blankets took about a year per blanket. Today they can be seen in museums, private collections and are again being worn at potlatches and ceremonies.

Interior of an 1800's Tlingit Chief's home, called the "Whale House". The wooden feast bowl, with the face carved at one end, represents a mythical giant woodworm, which a family ancestor called Kaakutchaan had found, and secretly adopted as her child. The creature was destroyed by the girl's parents however, after being discovered eating the food in the winter storehouses. The inconsolable girl died of grief. Her family claimed the woodworm as a family crest in her honor.
(Photo: Royal B.C Museum)

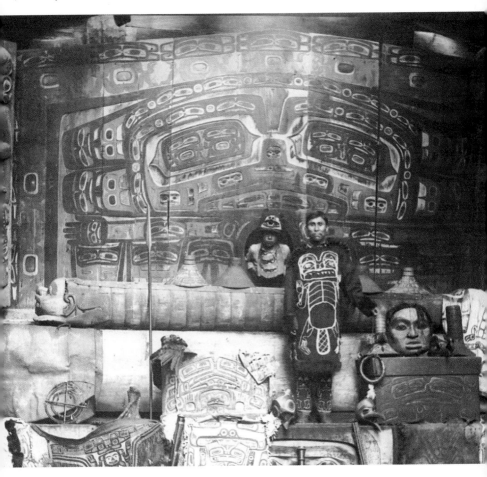

(right) Chilkat Blanket. Although the Tsimshian are credited with being the originators of the Chilkat blanket, it was the Tlingit who, in historic times, made them in large numbers and carried the art to its highest peak of development. They were traded down the coast and worn with great pride on ceremonial occasions by the Haida, Tsimshian, Kwakiutl, and Bella Coola chiefs who could afford them. On the death of the owner they were sometimes placed on the grave and allowed to disintegrate as a mark of esteem. Chilkat blankets were made from the inner bark of the cedar and from mountain goat wool and were woven by the women from a design drawn by a male artist on a pattern board. It has been recorded that many a heated discussion took place between the artists and the weavers who were trying to interpret the highly stylized totemic designs as closely as possible. The collection and preparations of materials, and the subsequent weaving of these fabulous blankets, with their bright colors of black, yellow, and greenish blue made from natural dyes, took about a year per blanket.

(below) Tlingit Chilkat dance skirt. (Photo: Princeton University, Museum of Natural History)

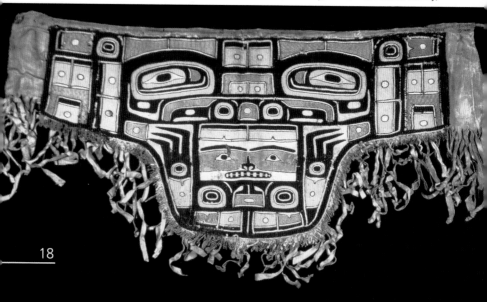

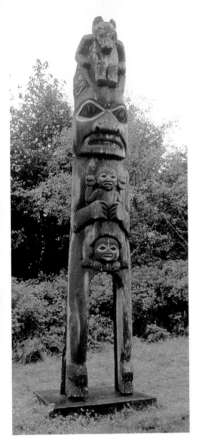

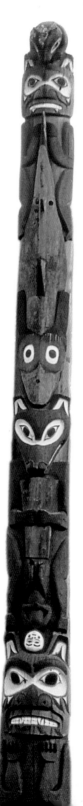

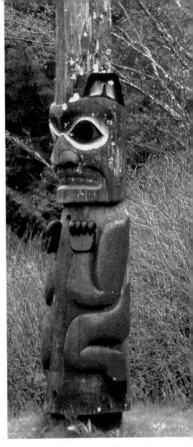

(above) Saxman village House pole of "Kats and his Bear Wife".

(right) "Dog Fish " pole. This restored mortuary pole commemorates the life of Tlingit Chief Ebbits who died in1880 at 100 years of age. The crests on this pole from top to bottom are: Bear, a wolf clan ancestor, Dog Fish, and Wolf holding a copper. The base of the pole is Bear, while the small upside-down person is a ridicule figure, representing the shame of an unpaid debt owed to Chief Ebbits and his heirs.

(above) The totem figure is from the Klawock "Black Fish Fin " pole. This totem pole was originally located at the now abandoned Tlingit village of Tongass on Cat Island. The totem figure represents a mythical sea creature with a bear's body and head, and the fin of a killer whale (extending out of the top of the picture). The Black Fish was believed to be an extremely powerful spirit, which could empower the crest owner with great hunting and fishing skills.

Haida poles at historic Skidegate.
(Photo: National Museum of Man)

Haida (Haida Gwaii)

*Haida argillite
carvings.*

The Haida (a name which means simply "people") were the most powerful tribe of Indians living on the Pacific coast of North America. Living in splendid isolation on the stormy Queen Charlotte Islands, and on the southern half of Prince of Wales Island to the north, the Haida frequently raided other tribes in their great war canoes, sometimes paddling as far south as Puget Sound in quest of plunder and slaves.

They were greatly influenced by their nearest neighbors, the Tlingit and Tsimshian tribes, successfully sharing the basketry and shamanistic rituals and songs of the Tlingit. But despite such extensive borrowing from other tribes, they were nonetheless an extremely creative and energetic people. Indeed, it has been said in ethnological circles by some enthusiasts, that the Haida carried Northwest Coast art to its greatest refinement, and this superiority was also evident in the construction of their long houses and in the building of their canoes.

Like their northern neighbors, they built gable-type houses with a partial ridgepole to support the roof, and the planks forming the walls were vertical. The measurements of Haida houses ranged from forty to fifty-five feet in length, and from thirty-five to fifty feet in width; the walls varied from twelve to nineteen feet in height. The carved house posts in the front walls of the houses stood anywhere from eighteen to fifty-five feet above the ground, and in the case of a great chief, a second heraldic pole was raised at the back, under the roof beam. In rare cases an oval opening, about three feet high, cut through the lowest section of these heraldic poles, served as an entrance, and provision was also made for an exit at the back of the house.

The canoes varied from small boats manned by one person, to great ocean-going canoes seventy feet long and capable of carrying

(below) Dogfish figure carved in argillite.

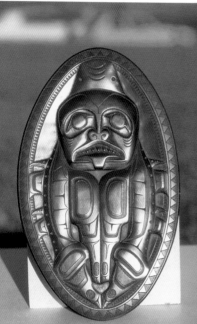

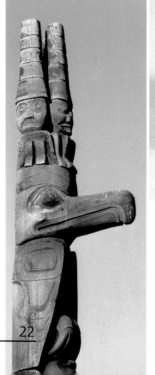

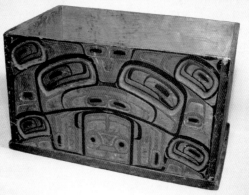

(above) Haida bent-box, painted with traditional black form-line and ovoid motifs of the Northwest Coast.

(left) Haida house front pole. The three figures perched on top of the Eagle's head are watchmen. It is thought that the watchmen's function was to alert the household of approaching danger.

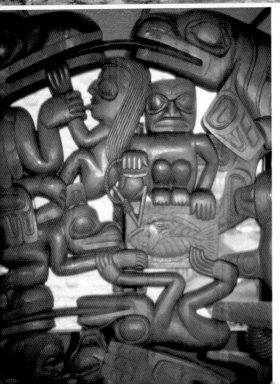

(above) Widening the canoe. Once the canoe has been hollowed out and shaped, the last step is to stretch the hull. This is achieved though a process in which rocks are heated in a fire and then are dropped into the water-filled cavity of the canoe. When the water begins to boil, tarps are fitted in place to keep the resulting steam trapped within. During this six-hour event, the softened cedar gradually becomes malleable enough for the builder to spread it open into a wider shape.

(left) Carved screen made by Haida artist Bill Reid
(Photo: Royal B.C. Museum)

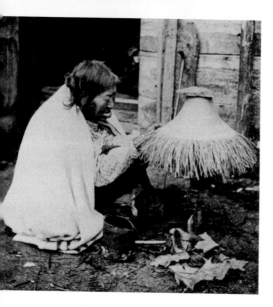

Haida Indian woman wearing a lip labret, weaving a rain hat at the ancient Haida village of Yan on the Queen Charlotte Islands. These rainproof hats were made from finely woven spruce root and finished with beautifully painted bird or animal designs in red, blue, and black.
(Royal B.C. Museum)

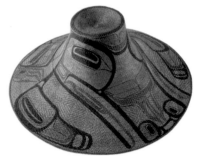

(above) Haida painted spruce hat. The stylized bird form can be recognized by the wing and claw motifs painted in black, red, and blue.

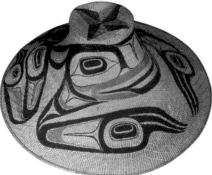

(above) The crest on this hat is a frog. Haida hats with crests painted on them were traditionally only worn by married women of upper rank. Hats were designed to effectively protect the wearer from both sun and rain. They fit quite snugly as an inner rim held the hat firmly in place.

(right) Haida hat with potlatch rings. Chiefs wore this tall style of hat, each woven ring displaying the number of potlatches a chief had given.

up to sixty people. As with other northern tribes in the coastal area, both the bow and the stern of Haida canoes were raised and projected above the water, whereas with the more southerly tribes in British Columbia, the canoe had a projecting bow but a vertical stern.

An awesome and thrilling sight to early voyagers were the ancient Haida villages of Skedans, Tanu, Masset, Skidegate, Yan, and others too numerous to mention. The houses were built in a line, close to the shoreline facing the sea, with the great carved totem poles rising high up above the roof tops and the giant canoes, with classic Haida designs frequently painted on the bows and sides, drawn up on the beaches; monuments indeed to the creative genius of a highly intelligent people.

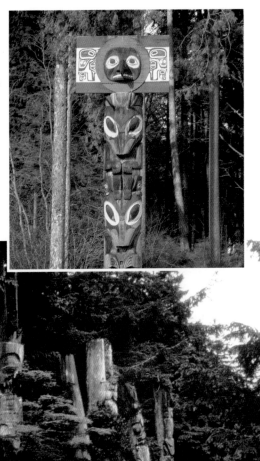

(right) Reproduction of a Haida mortuary pole, Stanley Park, Vancouver.

(below) Old Haida totems are being re-claimed by the forest, Anthony Island, Queen Charlotte Islands.

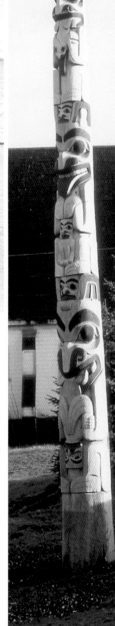

Haida artist Robert Davidson created this beautiful silk-screened print. It is a box design traditionally carved and painted on the bentwood boxes and storage chests belonging to chiefs.

Carved from red cedar and highlighted with red and black paint, this pole represents the legend of the berry-picker who was captured by the grizzly bears. Carved almost single-handedly by Robert Davidson, this totem pole has historic significance. The forty-foot totem was raised at the Haida village of old Masset on August 22nd, 1969, and received national press coverage. It was the first totem pole raised in the Charlottes since 1884.

The Haida did little hunting by land, although occasionally they killed a few of the black bears which ventured into open areas along the coast to eat berries, or feed on salmon at the edges of the streams. But due to their very isolation on the islands the Haida soon became great voyagers and mighty hunters of the sea. They traded heavily with the Tlingit and Tsimshian people, bartering seal furs and sea otter skins, and even their magnificent canoes, for the coveted Chilkat blankets, and for eulachon oil.

There are no reliable estimates of the Haida population prior to the coming of the explorers. Spanish navigators introduced small pox to the Tlingit people as far back as 1775, and epidemics raged up and down the coast taking a heavy toll of their helpless victims.

A fairly reliable estimate, taken in 1835, placed the Haida population at around six thousand. Further epidemics, introduced by settlers in Victoria, took a terrible toll of lives and the Haida were reduced to just a few hundred people by the latter part of the nineteenth century. Missionaries arriving on the Queen Charlottes in the 1800s found a shocked and broken people huddled in two villages, Masset and Skidegate — a far cry from the score or more well-populated areas of earlier days.

Missionary influences, backed up by the colonial government of the day, almost destroyed the old Haida culture and in a few short years only one totem pole was left standing in Skidegate and none at all in Masset. Today, saddened and enlightened British Columbians shake their heads in disbelief that such works of art, including masks, rattles, and other shamanistic paraphernalia, could have been so wantonly destroyed.

But all is not over for the Haida. Thanks to the determined efforts of a handful of Haida artists, like the now legendary Charles Edenshaw, and master carvers and silversmiths Bill Reid and Robert Davidson, the art has not been allowed to die. The Haida were the only Indians to carve in slate, the carbonaceous shale found only on Slatechuck Mountain in the Charlottes, and known to us as argillite. They zealously guard this deposit and, since they control the supply, continue to be the only carvers of argillite, finding a ready market for the glossy black miniature totem poles, ashtrays, bowls, and dishes. In times past such items were used to barter with the early traders, and today are bought by collectors and art lovers everywhere.

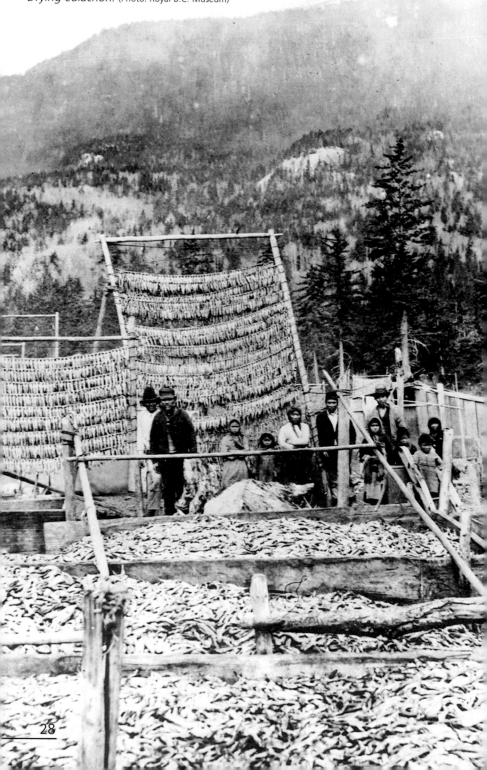

Drying eulachon. (Photo: Royal B.C. Museum)

Tsimshian

Symbol of 'Ksan Village.

Another coastal linguistic group, whose territory nevertheless extended much further inland than that of the Tlingit, was the Tsimshian ("people inside of the Skeena River"). They were divided into three groups, closely allied one with the other. There were the Tsimshian proper, who lived around the mouth of the Skeena River where it meets the sea; the Gitksan ("Skeena River people"), who lived further up the Skeena; and the Nisga'a, who inhabited the basin of the Nass River.

The art of the Tsimshian people was as prolific and fine as any on the Northwest Coast. From mountain goats and sheep they obtained wool for the weaving of blankets, and horns for the manufacture of spoons and ladles. The smaller, more delicate spoons were manufactured from the black horns of the mountain goat. By a process of steaming the horn and then fastening it into a mould, bowls were made; the handle was often exquisitely carved into animals or birds representing the family crests. Large spoons and ladles were made from the horns of the mountain sheep. Sometimes sheep horn was used for the ladle and goat horn for the handle, making a delightfully pleasing contrast in color and texture.

The manufacture of these wonderful old spoons and ladles was not, of course, confined only to the Tsimshian people. Other Northwest Coast tribes, notably the Haida and Tlingit, also successfully manufactured them. Today they are seldom made and have become extremely rare and valuable, most of them having long since found their way into museums and private collections.

Other rare collectors items are the beautiful portrait masks and wooden chests sculptured by the Tsimshian. The Tsimshian proper, living as they did close to the sea, hunted the seals, sea lions, and sea otters, around the islands off the coast, while the Nisga'a and Gitksan people directed their energies to hunting land animals, such

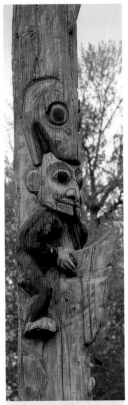

(left) Close-up of the "Dog-Salmon" pole located at the Tsimshian village of Kitwanga. The story of this pole is: A young man of the Raraotsen family cured the Salmon chief of an illness. In gratitude, the salmon of the stream appeared before the young man as humans in a canoe. They offered him a salmon suit, inviting him to swim with the salmon run. As he swam past his village, his uncle Raraotsen caught an enormous salmon of such size he could barely drag it out of the river. When he opened up the salmon, he found his nephew inside. This is how the family acquired the Dog-Salmon crest.

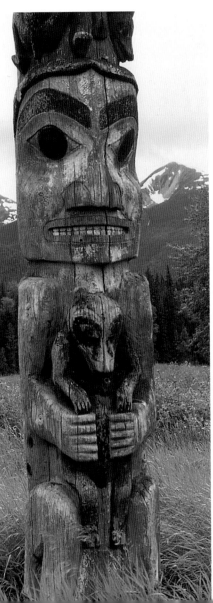

This Tsimshian totem pole is called "Pole-of-the-Wolf". It is located at Kitwanga village. The pole figure with the cub represents Hrpeesunt and her bear cub children.

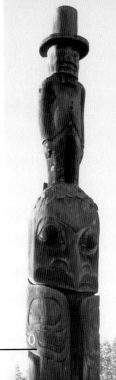

Tsimshian totem pole.

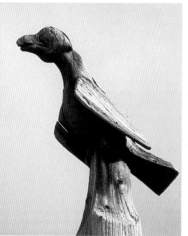

(above) Close-up of Grouse, a Tsimshian totem figure, perched on the top of the "Snag-of-the-Sand-Bar" pole at Gitsegyukla.

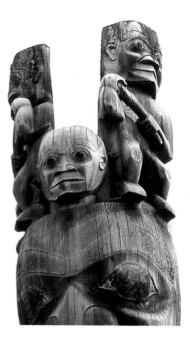

(far left) The "Pole-of-Trawawq", located at Gitwinlkul, has a bear figure on the top resting horizontally on a human's head.

The totem figure at the top of this Gitwinlkul pole is Split-Person, with two complete humans on his head.

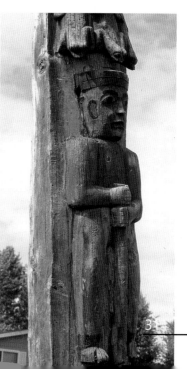

Close-up of a pole figure on the "Hanging Frog" totem at Kitwanga.

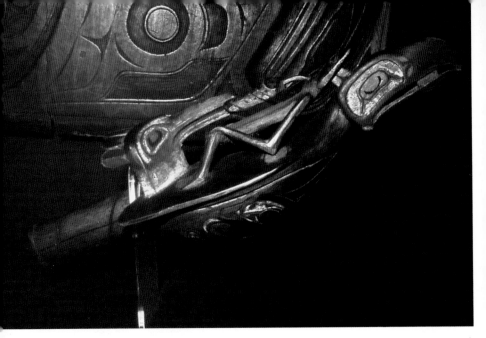

Raven rattles, or "chiefs' rattles", were originally shamanistic in origin and were used by all northern tribes. Chiefs, having spokespersons who made speeches on their behalf, would reinforce their words by shaking the rattle at key points. The rattle represents Raven, with the sun in his beak. The human figure uses his long tongue to borrow power from the raven.

'Ksan Village, Hazelton, B.C. This replica Gitksan village has become a contemporary training centre for Native arts. Artists have the opportunity to learn from instructors the Gitksan/Nisga'a design elements that make up the distinct ''Ksan style.

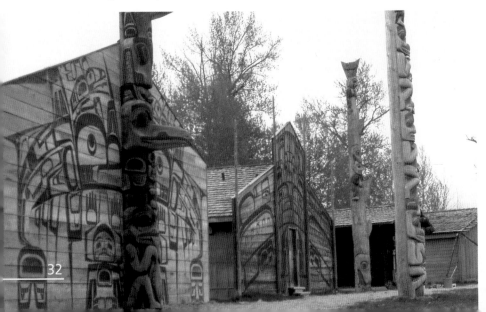

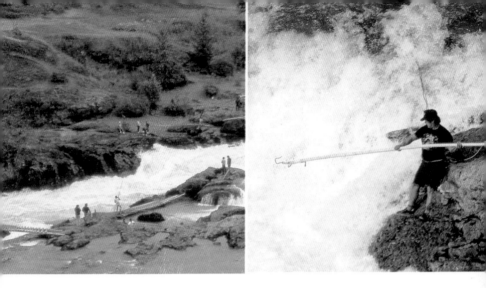

Tsimshian fishing in New Hazelton. Traditional fishing methods are still employed by Tsimshian fishermen. Steel gaff hooks attached to long shafts, are used to rake up the fish as they travel along the bottom of the stream during salmon runs. In the past, gaff hooks were made of wood, bone, antler, and later, iron.

as mountain goats, deer, and bears. It has been recorded that in those far-off days the salmon were so thick you could almost walk across the rivers on their backs. Certainly all three groups depended heavily on the salmon migrations up the rivers every year, salmon being their staple diet.

They also gathered together along the Nass River to fish for eulachon, sometimes known as "candle fish." These small fish, nine to twelve inches long, would arrive at the mouth of the Nass River in incredible numbers. Upon their arrival seals, sea lions, and whales pursued them while great flocks of seagulls, seabirds and eagles appeared every day to feed on them until dark. The Tsimshian trapped them in long, bag-shaped, wide-mouthed nets. They then boiled the fish by placing hot rocks in large wooden vessels, or even canoes. The water was thus kept boiling until the oil from the fish rose to the surface, where it was recovered after it had cooled.

Eulachon oil was highly prized by the Natives as a tasty fish sauce, and was also used as a condiment for smoked meats and even such dishes as dried berries. Trade in eulachon oil was very extensive and long trails, known as "grease trails" led into the interior, where the Tsimshian met and traded with the Athapaskan-speaking

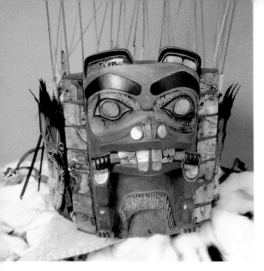

(left) Chiefs frontlet. Decorated with abalone shell, red flicker feathers, and woven spruce root. The protruding strands at the top are sea lion whiskers, while the fur lining the bottom is of ermine. The crest carved on the front is Beaver. Chiefs' headdresses were first created by the Tsimshian, but worn and prized by chiefs of all northern tribes. In the early days, frontlets exchanged hands through trade or raids.

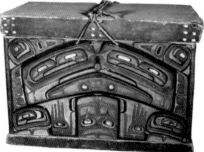

(right) Tsimshian carved chest. (National Museum of Man, Ottawa.) Boxes were made of cedar boards, bent by a steaming process to form four corners. The bottom and last seam was then pegged tightly together, making it quite capable of storing oil or holding water. The plain boxes were used for cooking or storage, while the exquisitely carved and painted chests, were owned by chiefs, holding dance regalia or other items of wealth.

tribes. They also heavily traded the coveted oil among other Northwest Coast tribes, transporting it in their canoes.

In their daily lives the Tsimshian people paralleled the Haida in many ways. They had similar customs and beliefs and held feasts and gave great potlatches to celebrate important events, such as the erection of a new totem pole or the assumption of an ancestral name. Medicine men practiced their art and rituals in the same way, acquiring their status either by purification and fasting, as among the Haida, or by sudden and complete recovery from a near fatal sickness. The recovery, of course, was then regarded as positive proof they had the power to heal similar maladies in others.

In 1835 the population of the Tsimshian was estimated at 8,500. By 1895, their lowest year, it had dropped to 3,550 due to the ravages of the disease. Nevertheless, they were not so hard hit as some of the other Northwest Coast tribes, probably due to the inland isolation of many of their villages. Many of them greeted the early settlers' intrusion with cold hostility, and tried to isolate themselves by

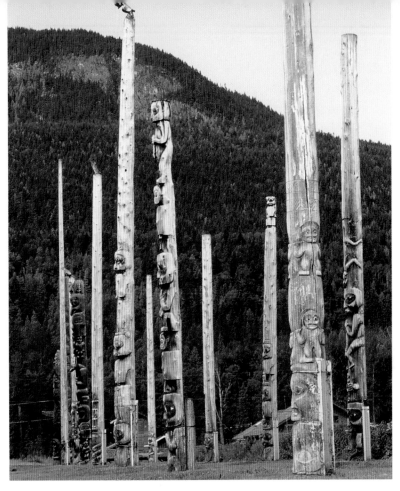

Tsimshian totem poles located at Kispiox Village, B.C.

withdrawing into their villages and attempting, as far as possible, to hang on to their old ways.

The best stands of totem poles in all of British Columbia are still to be seen in the area of old Hazelton, and at Tsimshian villages with such romantic names as Kitwanga, Kitwancool, and Kispiox.

With the opening of the model Tsimshian village at '"Ksan, the arts of the Gitksan, the Nisga'a, and the coastal Tsimshian made a stunning comeback, and the discerning collector can again purchase masks, rattles, storage boxes, small totem poles, and even hand engraved jewelry, comparing very favorably in quality with the work turned out during the latter part of the nineteenth century, when Tsimshian art had developed to its peak.

Kwakiutl Indian woman wearing a woven cloak of shredded cedar bark trimmed with fur. Her face is adorned with two large earrings cut from abalone shell. (E.S. Curtis)

Kwakiutl (Kwakwaka'wakw)

The Kwakiutl Indians occupied the northern corner of Vancouver Island from Johnstone Strait to Cape Cook, and the coast of the mainland from the head of Douglas Channel to Bute Inlet, with the exception of a small area controlled by the Bella Coola people.

The Kwakiutl were imaginative people, and this characteristic was graphically mirrored in Kwakiutl art which, like that of the Bella Coola, was noticeably different from the more stylized work of the Tlingit, Haida, Coast Salish, and Tsimshian people. The Kwakiutl did not feel bound by the strict conventions of the northern art styles, and carved figures on totem poles were not necessarily contained "within the block". Instead they felt free to add beaks, wings, arms, or other appendages, their art being freely rooted in the sculptural traditions of older times on the coast. They loved bright colors, and in later times adopted commercial paints when painting designs on their house fronts, masks, and totem poles.

The entire structure of their highly organized society was based on the potlatch, as indeed it was with all of the Northwest Coast tribes. The potlatch was a rather complicated "giving away" ceremony, in which the recipients of lavish gifts were bound to recipro-

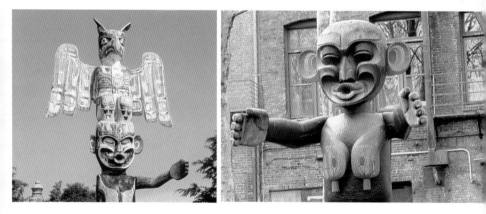

The D'sonoqua figure featured on these Kwakiutl totems represents a mythical Wild-Woman-of-the-Woods. This terrifying creature was believed to lurk through the woods with a basket for collecting children on her back. One would know she was near if a hooting sound was heard from her pursed lips. D'sonoqua was a desirable family crest, however, as a bringer of wealth and good fortune. During Kwakiutl potlatches, D'sonoqua would be the one to bring coppers to the chief.
(above left: Alert Bay, B.C; above right: Seattle, Washington.) 37

Artist, Bob Peasley, adding the finishing touches to a mask. The hair is made from a cow's tail.

(below) Kwakiutl, Alert Bay (below) Kwakiutl, Fort Rupert

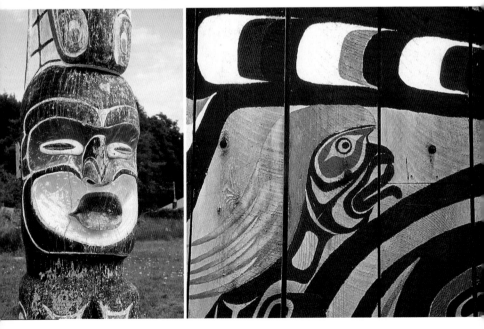

(right) Kwakiutl Sun mask made by Gene Brabant.

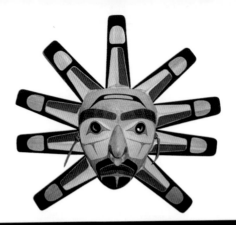

(below) Kwakiutl "Guax-Wiwi" (Raven's wife) mask. One of the cannibal ravens used in the winter Hamatsa dances. Its beak is hinged and, by pulling strings, would clack together in time with the drummer's beating of batons.

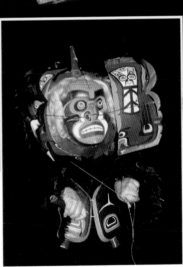

Kwakiutl transformation mask. This type of mask has one face on the outside and another hidden within that is revealed, during the dance, with a pull of the string. This mask, which was used during Chief Don Assu's potlatch, features D'sonoqua on the outside, and Bokwas — the Wild-Man-of-the-Woods — inside. Supernatural Bokwas is believed to live in an invisible house in the woods that is often visited by drowned spirits. Desiring the company of humans, he would try to feed the people he encountered a substance that looked like dried salmon, but really was ghost food (rotten wood and grubs). Enchanted, they would remain with him in the woods forever. (Photo: Mia Hancock)

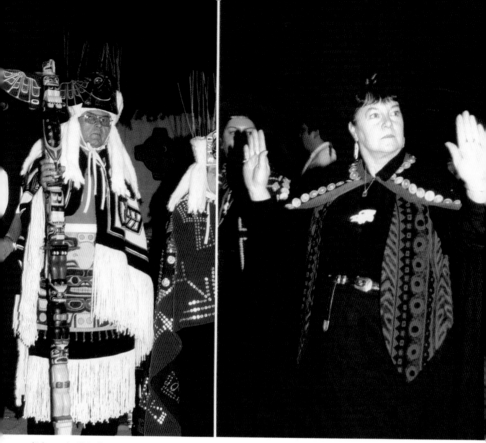

(Above) Chief Don Assu's potlatch. The Chief is holding a speaking staff and wearing a Chilkat blanket robe.
(Photos: Mia Hancock)

(Above) Patty Fawn, a fine jewelry artist, is also a classic dancer.

(Below) The drummers beat time and create a mesmerizing atmosphere.

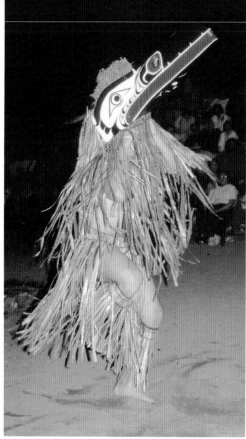

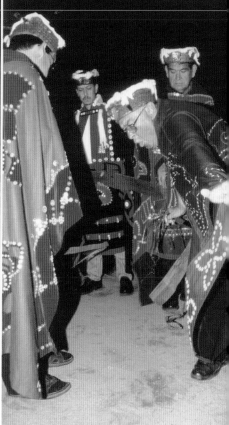

Dancer retells family stories and claims of greatness.

Village historian oversees potlatch etiquette.

Chief Don Assu's brother distributes gifts to potlatch witnesses.

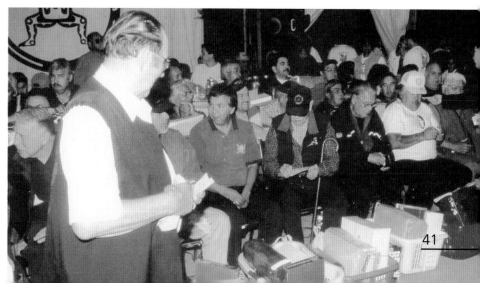

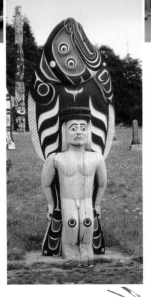

(above) Kwakiutl house front with Sisuitl painted on it, Alert Bay, B.C. The two-headed monster, Sisuitl, is well known though out the Northwest Coast. It is the assistant of Winalaglis, the warrior spirit, and possesses the ability to cause death to its enemies with just one glance. This crest is often used on house fronts, feast bowls, spears, and the headdresses of warrior dancers.

(left) Kwakiutl memorial pole with a halibut crest behind the figure of a man, Alert Bay, B.C.

This Kwakiutl memorial carving has abalone shell adorning the cedar headdress.

cate by inviting the donors to a return potlatch, where they were bound to prove their standing and influence by giving back far more than they had received. These endless potlatches, and the fantastic ceremonial rituals that were so much a part of it all, fed and encouraged the natural creative urges of the Native people.

When the potlatch, along with its accompanying dances and shamanistic rituals, was banned by the government in 1884 because of its impoverishing effects, the final blow had been delivered and the culture collapsed almost at once.

But the Kwakiutl, perhaps a little more assertive in their character than other tribes, did not give up easily. They went underground, carrying on the secret society dances, and even the potlatches, as best they could in undeveloped areas where they were not likely to be caught. Some were eventually jailed for it, yet the old customs never really died among the Kwakiutl. The potlatch ban was lifted in 1951

Unlike other tribes, they never did stop carving totem poles, and a very fine stand of them, showing Kwakiutl art at its greatest development, can be seen at Alert Bay where a truly splendid memorial pole, carved by master carvers Henry and Tony Hunt, was raised in 1970 to honor master carver Mungo Martin. Significantly, the project received the whole-hearted support of the government, a far cry from the policy of colonial days.

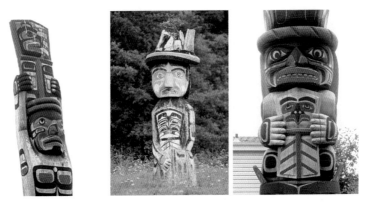

Three Kwakiutl memorial figures holding coppers. Coppers on mortuary poles represent the ancient hammered copper shields that were symbols of wealth and great personal esteem. To own one was considered to be the pinnacle of achievement, each copper being worth thousands of blankets, or from fifteen to twenty slaves. Individual coppers were named, and when a copper was sold its value increased, giving its new owner an even greater measure of prestige than the previous owner had.

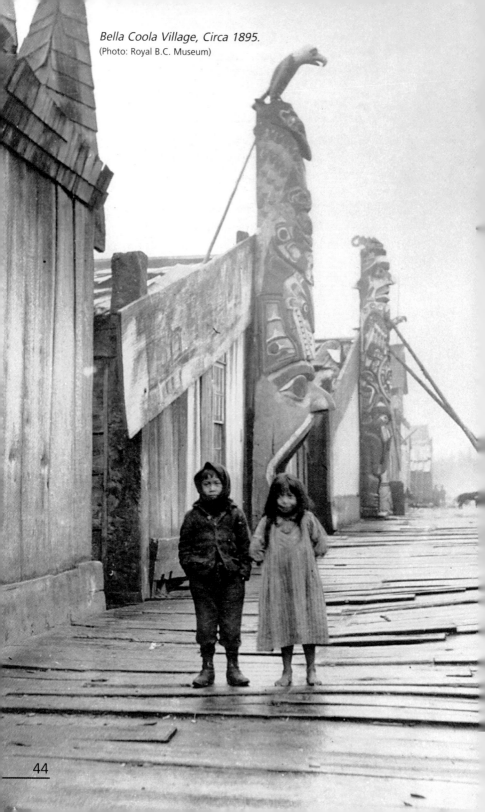

Bella Coola Village, Circa 1895.
(Photo: Royal B.C. Museum)

Bella Coola

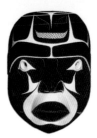

*Bella Coola mask by
Gene Brabant.*

Hemmed in on three sides by the Kwakiutl, and indeed, jutting into Kwakiutl territory to a point where it almost divided them in two, was the land of the Bella Coola people. Their villages faced the Dean and Bella Coola Rivers, and were also built along the fjords into which these rivers flow. Each village contained anywhere from two to thirty plank houses built in a row facing the waterfront, and each house sheltered from two to ten families.

The Bella Coola were originally a Salish-speaking people who possibly broke away from the main body to the south of them, and trekked across the mountains to their present location. Their staple diet was salmon and eulachon, but they also ate wild goats, geese, ducks, bears, porcupines, and seals, as well as enjoying an abundance of wild berries and roots.

The Bella Coola were understandably greatly influenced by both the interior Athapaskan to the east and their Kwakiutl neighbors. Bella Coola art has often been linked with that of the Kwakiutl, but there were subtle differences, usually fairly obvious to the trained eyes of ethnologists and collectors of Native art. The differences were especially obvious in their beautiful totems.

Like the Kwakiutl, the Bella Coola's carved masks that depicted great mythical monster birds. These masks, which were sometimes up to five feet in length, had very long movable beaks that would clack in lively fashion when concealed ropes were pulled. They were brightly decorated with red, white, black, and green or blue paint, and heavily fringed with long strands of shredded cedar bark and were used extensively in the secret society dances.

Never a numerous people the population census of 1835 listed only 2,000 Bella Coola and due to exposure to disease they had been reduced to 249 people. Throughout the twentieth century, however, their population, along with their cultural identity, regained strength.

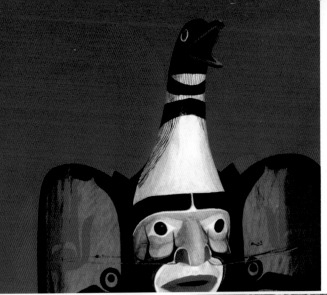

(left) Bella Coola-styled transformation mask of a loon, from Lelooska Foundation. When the wings are opened the face of Komokwa, the ruler of the undersea world, is revealed. Loons and other diving sea birds are associated with this entity, as a link between the two worlds.

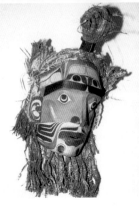

(above) Bella Coola-style shaman mask of alder, cedar bark and feathers by Duane Pasco.

(right) Bella Coola dancer.
(Photo: Department of Mines, Geological Survey)

(opposite page) Close-up of a Bella Coola eagle and the center face of Sisuitl, carved on a grave post.

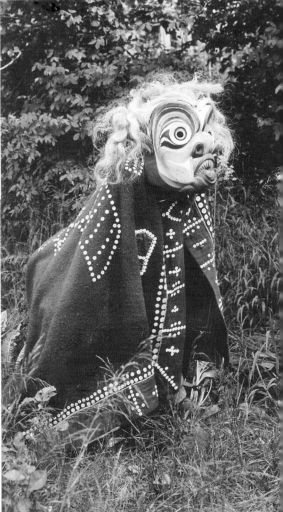

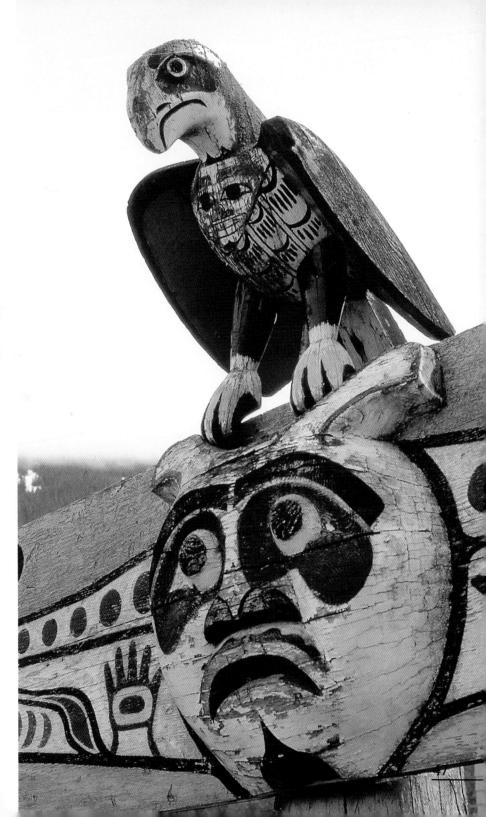

(above) The interior of a Bella Coola longhouse, Komskotes Village, 1920.
(Photo: Department of Mines, Geological Survey)

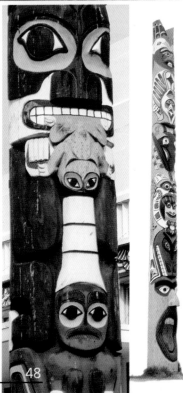

(left) Bella Coola totem poles.

(opposite page) Bella Coola eagle memorial pole.

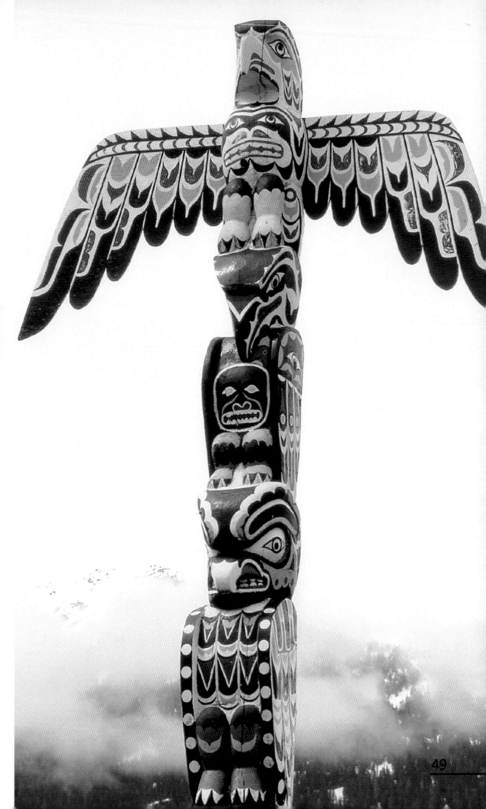

Early West Coast fisherman. The Nootka used many types of spears and harpoons for fishing salmon. Each one customized to the different fishing environments. This type of harpoon was used in deep wide rivers, or in the sea where the salmon surface.

Nootka (Nuu-chah-nulth)

(right) This style of hat was traditionally worn by Nootka chiefs. Hats, with out the top knob, were worn by the rest of the community. Whales and whale hunting motifs were commonly woven into Nootka hats.

When we refer to the arts of the Indians of the Northwest Coast, we usually mean the five northern tribes comprised of the Tlingit, Haida, Tsimshian, Kwakiutl, and Bella Coola. Little has been documented on Nootka art, yet the Nootka people, inhabiting the west coast of Vancouver Island from Cape Cook to Port San Juan, were also a vigorously creative and artistic tribe.

In past times they were divided into twenty-five different groups. Twenty-four of these groups dwelled in British Columbia and the remaining group, the Makah, lived on the northern Washington coast.

The Nootka were courageous whalers and it is highly probable that they were the only tribe to regularly hunt the great whales. Nootka men were trained from early childhood in the management of their sturdy dugout canoes, and frequently paddled beyond sight of the stormy coastline in search of their ocean prey. Fish, particularly salmon, herring, and halibut, furnished the main food supply, but they also hunted seals, sea lions, and sea otters, while women

Nootka dancers.

(above) Weathered Nootka welcoming figure. Welcoming figures were erected, facing the sea, to greet visitors who were arriving by canoe. Besides being a polite gesture, welcoming figures were effective reminders of who owned the beach.

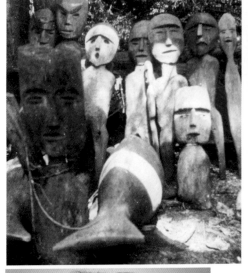

(right) Nootka whaling shrine. The statues represent the bodies of whalers who were killed during a whaling expedition. Nootka chiefs would sing and pray at these shrines for whales to be washed ashore or for the success of a whaling venture, offering the figures as symbolic food for the souls of dead whales. The Nootka believed that this would help to lure live whales to them. Human skulls, used by chiefs at these sites, have been reported to tip over if a whale was approaching the beach.

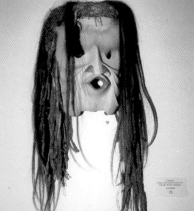

Pokmus mask by Loren White. Pokmus is the Nootka ghost of drowned whalers.

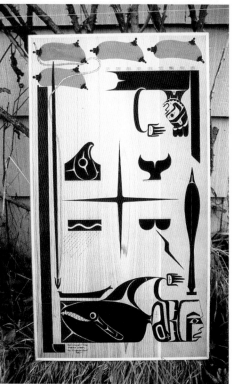

Two serigraphs by Hupquatchew (Ron Hamilton) of the Opetchesaht tribe.

and children dug for clams along the sea shore, or gathered roots and berries for further variety in the diet.

Clothing, when worn at all, was similar to other coastal tribes. The women wore a fringed skirt, woven from shredded cedar bark. Nootka men usually preferred to go around without clothing of any kind, although sometimes in rainy weather they wore a cape of cat-tails or cedar bark. For special occasions, the nobles of the tribe wore robes of bearskin, lynx, or marten; even more beautiful were robes made by the women from the inner bark of the cedar and edged with otter fur.

The hats worn by Nootka men were also made by the women from very finely woven spruce root or cedar bark fibers. Clever designs were woven into the hats, rather than painted on them, as with the more northern tribes. These designs often depicted a whale hunt, with warriors in canoes attempting to harpoon the whale, sometimes under the watchful eyes of the mighty Thunderbird, a mythical spirit-bird in the form of an eagle, famous in Nootka leg-

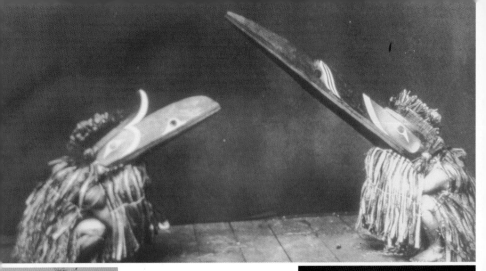

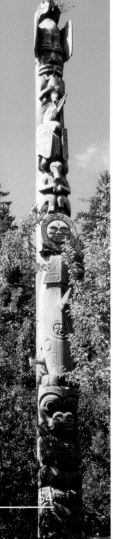

(above) Nootka dancers wearing masks representing legendary mythical Nootka monster birds, 1914. (Photo: E.S. Curtis)

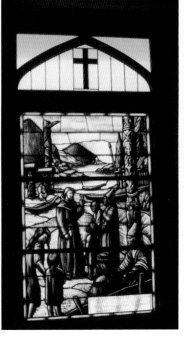

(left) Old Nootka totem pole at Esperanza inlet, Graveyard Bay.

(right) Stained glass window at Friendly Cove depicting the meeting between Europeans and Natives.

(opposite) Section of a Nootka totem pole at an abandoned Nootka village on Esperanza inlet, Graveyard Bay. The power and stark beauty of Nootka art is revealed in this close-up view of a bear holding a frightened man between his paws.

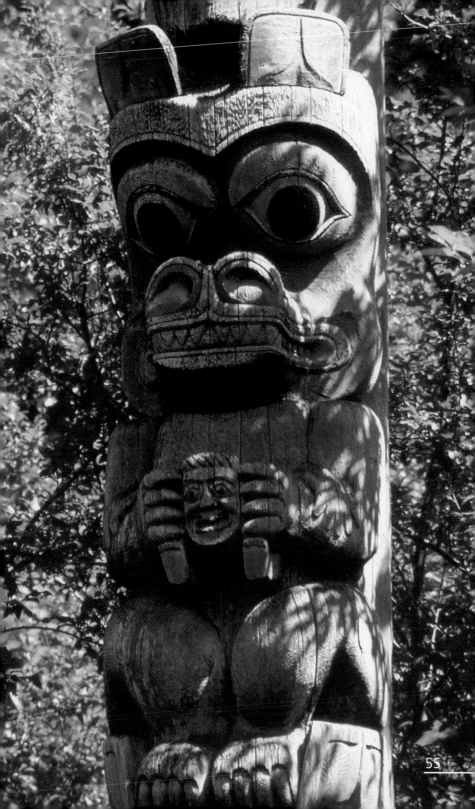

Nootka burial site. The Nootka would wrap the dead in cedar bark mats, and place them in boxes. The boxes would either be tied high up in a tree, or placed in a cave in a wooded area, some distance from the village.

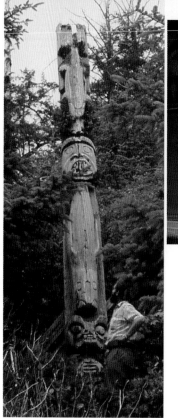

(right) Nootka totem pole.

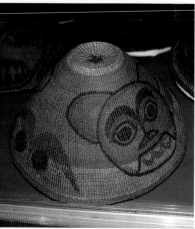

(above) Nootka hat.

ends and among other Northwest Coast tribes, notably the Kwakiutl and the Salish.

The Nootka built huge plank houses, usually with flat, shed-type roofs and, like their Kwakiutl neighbors, had carved inside house posts supporting the roof beams. They did not begin carving outside totem poles until the latter part of the nineteenth century, and this practice soon ceased under the influence of early missionaries. However, there are a few poles still standing in the vicinity of ancient Nootka villages and graveyards which, although weathered with age and minus most of the paint which once so complimented and adorned them, continue to reveal a stark beauty and to emanate a power reminiscent of the work of more northerly coastal tribes.

Nootka women are justly famous for the high quality of their basketry, with splendid designs depicting whale hunts and Nootka legends of the Wolf and Thunderbird or perhaps the mythical Haietlik, the Lightning Snake. These baskets, woven of bear or sweet grass, are still made, many with as fine a weave as in the past.

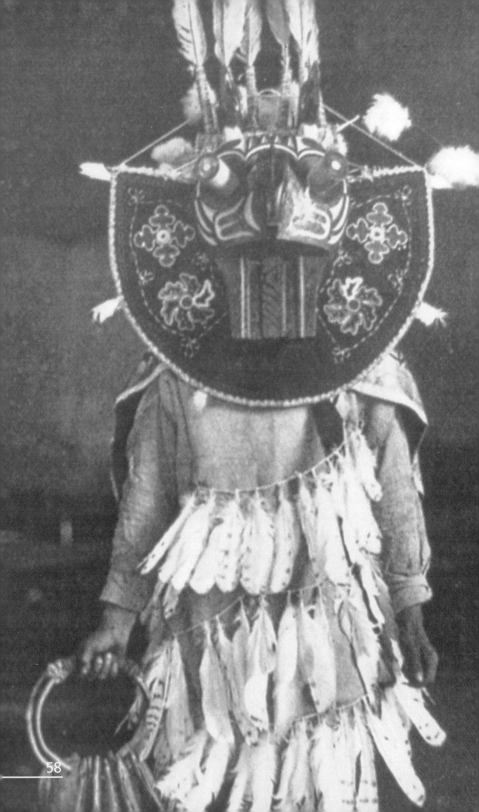

Coast Salish

The Coast Salish Indians were neighbors of the Nootka and Kwakiutl people, but did not exercise the same interest in carving and painting. They inhabited the coast of the mainland, from Bute Inlet to the Columbia River, and those areas on Vancouver Island not occupied by the Kwakiutl and the Nootka, from Johnstone Strait to Port San Juan.

Historically the Coast Salish Indians did not carve totem poles, although carved welcoming figures, house posts, and mortuary figures were noted by early pioneers. The welcoming figures, standing ten to twenty feet in height, were an awesome sight and caused much comment among travelers seeing them for the first time. The figure was that of a man, sometimes wearing a hat and short cape, but usually nude with pegged on arms both of which were raised in a welcoming salute.

Coast Salish women made fine baskets, with imbricated designs. They also wove handsome, fringed blankets from the sheared wool of a small, white dog which was kept for that purpose. The Coast Salish placed a high value on the hair of these dogs which was similar to sheep's wool. The dogs were shorn of their coats at intervals, and the wool used — usually along with that of the mountain goat — in the weaving of Salish blankets.

With the arrival of the explorers and traders, and the establishment of Hudson's Bay trading posts, the Salish people were soon able to acquire the famous Hudson's Bay blankets and no longer found it

(left) A masked Cowichan dancer. He is wearing a Skhway Khwey mask. These famous masks are still used in Coast Salish secret society ceremonial dances. (Photo: E.S. Curtis)

(right) Coast Salish artist, Simon Charlie, holding his carving of a Skhway Khwey mask.

59

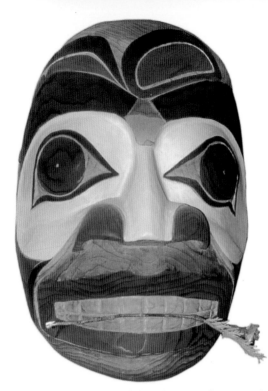

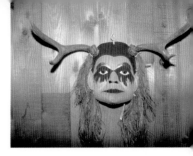

(left and above) Two contemporary Coast Salish masks at the Xa:ytem Native Heritage Centre.

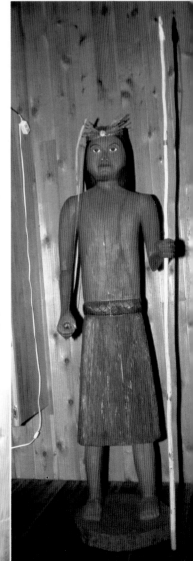

(right) Coast Salish welcoming figure at the Xa:ytem Native Heritage Centre. Coast Salish artists were not required to display family crests on carvings, allowing their work to have simplicity of form. Often, only a few raised figures on a flat board, or tall welcoming figures with out-stretched arms were carved

(below) Among the Coast Salish and other southern groups, houses were often built with shed-styled roofs and a hearth for each family unit. The houses were sometimes built end-to-end, each linked by a doorway in between. This continuous structure was sometimes large enough to include the entire village.

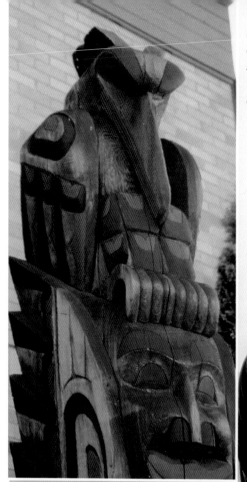

(left) Close-up of a Coast Salish totem figure of Raven, Duncan B.C.

(above) Coast Salish ceremonial attire worn during the Spirit Dance. The jacket is decorated with many small wooden paddles.

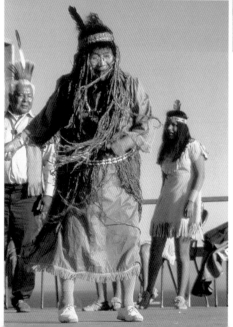

(left) Coast Salish dancers.

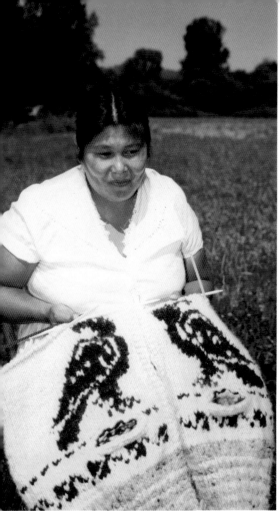

(above) Coast Salish spindle whorl, Campbell River Gift Shop.

(above) Coast Salish spindle whorl created by Luke Marston.

(below) Coast Salish weaver.

(above) Coast Salish woman knitting a Cowichan sweater.

(below) A Coast Salish loom with spindle whorl and bale of goat wool, Mission Heritage Centre.

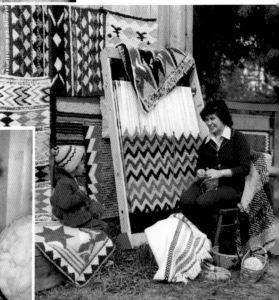

necessary to go through the tedious process of weaving their own on primitive looms. The dogs were no longer a valuable commodity, and soon became extinct, probably due to interbreeding with dogs brought in by settlers and gradually acquired by the Indians as pets.

The Salish produced beautiful natural dyes for coloring their blankets with attractive geometrical patterns. Alder bark was used for red; lichen for yellow cedar and hemlock bark for brown; Oregon grape for a yellow-green and copper for blue-green. For dress-up occasions and ceremonies, Salish men sometimes wore a high conical hat, made of human hair and crowned with two duck or loon feathers which were cleverly fastened to a short spindle embedded in the pinnacle of the hat. The slightest movement of the wearer would cause the feathers to sway rhythmically back and forth. These hair hats were used in spirit dance ceremonies along with a beautiful buckskin costume sewn over with tiny paddles.

The staple diet of the Coast Salish, as with other coastal tribes, was fish supplemented by the meat of wild goats and deer.

They built shed-type houses with flat roofs which inclined upwards from front to rear, or vice versa. The great width of these shed houses, forty feet or more, gave the roofs a gentle pitch. This made the roofs very useful for drying fish and also provided a handy platform for spectators at potlatches and other ceremonial gatherings and festivities.

The Coast Salish group was the most numerous of all the coastal tribes; in British Columbia alone the population census of 1835 placed their numbers at 12,000. By 1915, their low year, the usual plagues and diseases had reduced the population to just over 4000. However, their numbers rebounded throughout the twentieth century.

Coast Salish canoe racing competition held at Vancouver B.C.

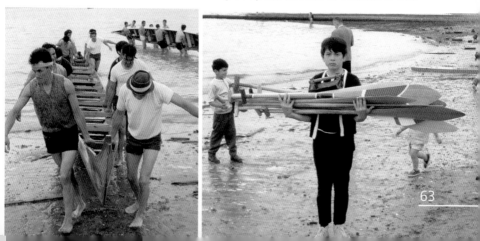

Interior Salish girl with her hair specially braided to mark the termination of her adolescence.
(Photo: National Museum of Man)

Interior Salish

Wasco Salish basketry.

The Interior Salish Indians were dissimilar in many ways to their Coast Salish neighbors. They had different customs; they spoke in different languages and dialects and, according to some sources, even differed in physical appearance. The Interior Salish group was not a united people, being divided into five tribes which were continuously battling with each other.

First there were the Lillooet or Wild Onion Indians of the Lillooet River valley. Second, the Thompson River Indians inhabited the Fraser River valley from Yale to Lillooet, and on the Thompson River as far up as Ashcroft. Third, there were the Okanagan Indians of the Okanagan Lake and River. The fourth tribe was the Lake Indians of the Arrow Lakes and Upper Columbia River. Fifth, were the Shuswap Indians, controlling the Fraser River valley from Lillooet to Alexandria, and all the country eastward to the summits of the Rocky Mountains.

Collectively speaking, and despite their small wars with each other, the Interior Salish formed the largest linguistic group in the interior of British Columbia and their territory extended well south into the States of Washington and Idaho. In 1835 the population of the Interior Salish was estimated to be 13,500.

They did a little carving and painting but never approached the levels achieved by the coastal tribes in artistic skills. Yet the women of all five tribes excelled in the craft of basketry. They decorated their baskets externally with beautifully imbri- cated designs of red and black cherry bark and white bulrush, with wonderful zigzag patterns representing waves or arrowheads and including animals, birds, and insects. The only other people who made comparable baskets were the Chilcotin and some of the Coast Salish, both of whom learned the art from the Interior Salish.

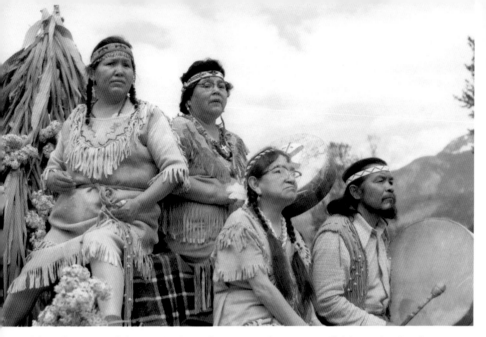

(above) Coast Salish Mt. Currie Rodeo. Horses became available to the Southern Plateau in the 18th century, and along with them came an introduction to the Plains culture. By the 19th century, plains-style shirts, leggings, and buckskin dresses had begun to replace the Salish style of clothing, which was robes for men, and goat skin or mountain sheep skin tunics for women.

(below) Ernie Philip, a Shuswap Okanagan dancer, performs the Eagle Dance at a Cultus Lake festival. (Photo: Jack Ralph)

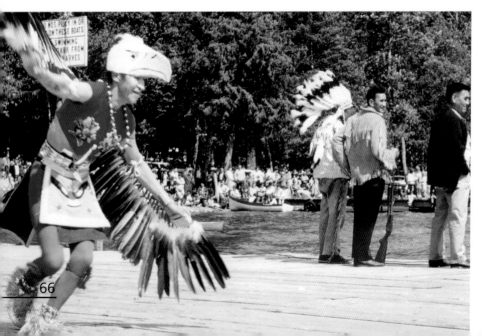

Salish war dance at Camosun College, Victoria, B.C., performed by the Shuswap Okanagan tribe. Although warfare was not a regular activity, the Shuswap Salish did have battles with the Chilcotin tribes. On occasion many Salish groups raided other villages, either in revenge, or to capture slaves, and were under constant threat by the more warring northern coastal tribes. Unlike other people or groups, the Interior Salish were known to poison their arrows with rattle snake venom or poisonous plants, using a special quiver made of dog skin to carry them.

(Photo: Jack Ralph)

Interior Salish summer shelters were of a conical design with rush matting.

A Nit Nat Salish weaver.

(left) Salish baskets, Lillooet Museum. The Interior Salish created such tightly woven baskets that they could be used for the stone-boiling method of cooking. The food was boiled by dropping fire-heated rocks into a basket of water.

Coast Salish Mt. Currie basket maker.
(Photo: National Museum of Man)

A Thompson River Indian, poses in front of his lodge in Plains Indian regalia: a magnificent headdress of eagle feathers, with a beaded and fringed buckskin costume, complete with moccasins.
(Photo: National Museum of Man)

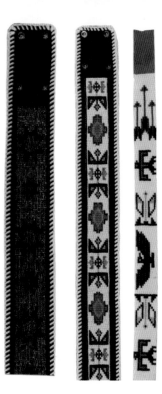

(above) Interior Salish beadwork. Originally beads were made from porcupine quills, fish, and bird bones. Glass and plastic beads are in common use today.

(right) Modern dance costumes combining interior and Coastal influences, the dentalium shells being from the coast Salish, the beadwork from interior styles, and the brocade being European in origin.

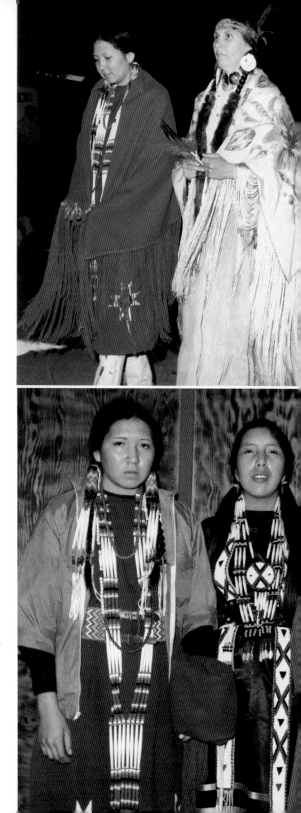

The winter home of these people was a circular semi-subterranean house around forty-five feet in diameter and entered by a notched log from the roof. The summer home was an oblong or conical lodge covered with rush mats. Both the summer and winter dwellings, with their dark and airless interiors, were in stark contrast to the great, spacious lodges built from red cedar by the coastal tribes. Because of their nomadic nature, larger, more permanent homes were unsuitable.

Due to the harsher climate of the interior, the Interior Salish were forced to wear protective clothing in order to keep warm. During the summer months the women wore a kind of tunic and the men nothing but a breechcloth. But for cold weather they had robes of fur, and leggings and moccasins of dressed skin.

For traveling, some families had dugout canoes similar to the river canoes used in the delta of the Fraser by the coastal people. But most preferred the easily made bark canoes. Most of their journeys, however, had to be made on foot due to the dangerous rapids of the turbulent Fraser and Columbia Rivers and their tributaries.

Salmon remained their principal source of food but, cut off as they were from the sea mammals, the Interior Salish hunted and trapped the land animals extensively. Bear, beaver, marmot, elk, and deer were prominent in their diet.

They traded heavily with the Coast Salish, bartering hemp, skins, bark, and goat's wool for shells, slaves, smoked beach foods, and occasionally dugout canoes.

The Interior Salish fared better than the coastal tribes at surviving diseases brought by the Europeans but their population still suffered a severe blow. Like most other Indian tribes, they are developing a strong pride in their cultural identity.

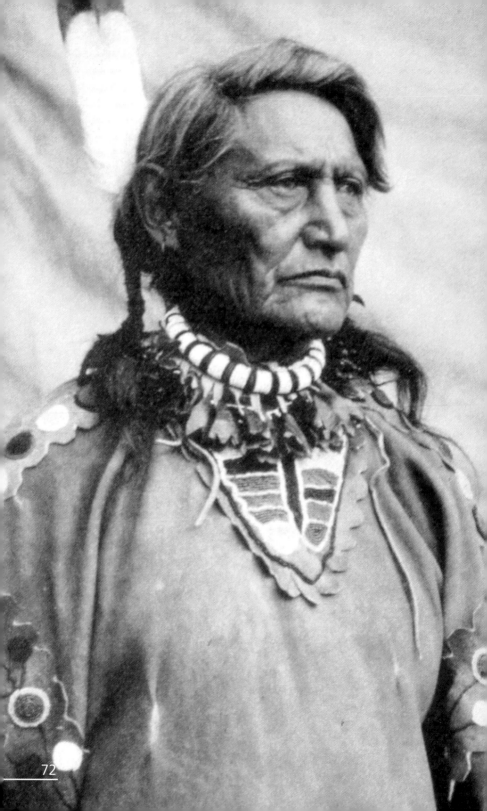

Kootenay

(left) Old photo of Chief Paul Daird of the Kootenay Indians in Utlak dress. (Photo: National Museum Of Man)

The Kootenay Indians, tall and fine-featured, resembled the plains tribes in dress, customs and religion. Indeed, it has been established that they lived on the Eastern side of the Rockies until the early half of the eighteenth century, but were harassed and driven westward by the Blackfoot who forced them to retreat across the mountains. They settled in the northern part of the State of Idaho, and the southeastern corner of British Columbia between the Rocky Mountains and the Selkirks.

They seem to have divided themselves into two groups: The Upper Kootenay, of the upper Columbia and upper Kootenay Rivers, frequently crossed the mountains to hunt the buffalo on the prairies. The Lower Kootenay, of the lower Kootenay River, spoke a slightly different dialect and, being further removed from the mountains, seldom joined in the buffalo hunts, subsisting mainly on fish.

Like the Plains Indians, they wore beautiful headdresses of eagle feathers and their dress, consisting of a shirt, breechcloth, leggings, and moccasins, was made entirely of skin.

Their dwellings, like those of the Blackfoot and other Plains Indians, were the conical tepees or wigwams, with buffalo hides or rush mats stretched around a framework of long poles.

The Kootenay also emulated the Plains people by painting designs on their tepees, garments, and even their bodies. Many of those designs reflected elements seen in power visions, dreams or guardian spirits.

The Lower Kootenay were affected to a certain extent by the

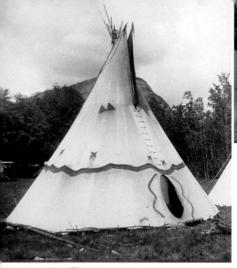

(above) Contemporary cloth teepee.

(left) 1915 cloth teepee, typical of kootenay and Plains people.
(Photo: National Museum Of Man)

Indian Travois. The travois was a type of sled constructed between a framework of two poles that served as a shaft for the horse. It was used extensively by nomadic Indians as an ingenious method of transporting their belongings when changing camp. Before the horse became available, dogs were used to pull a smaller travois.

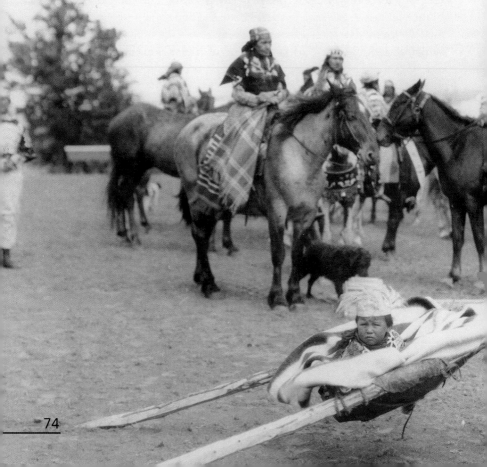

(left) Buffalo skins were used to cover teepee frames before fabric became the replacement. An average-sized dwelling would require from twelve to sixteen skins and sixteen poles usually made from lodge-pole pines. Teepee construction gave these pines their name. Teepees were made and owned by the women of the tribe. A common jest among old men was "a good set of teepee poles was more valuable than a wife". (Leechman.)

(right) Plains-style feather headdresses were made from the tail feathers of the golden eagle. Birds that were two years old were the most valuable, as these birds' tail feathers had the desirable black tips and white bodies. The feathers of bald eagles were not used in dance costumes or in religeous ceremonies of plains Indian powwow dancers.

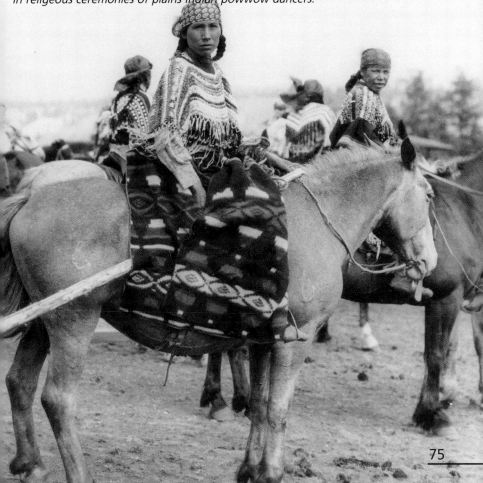

customs of the neighboring Salish, from whom they probably learned the art of making watertight baskets of split roots. Both the Lower and Upper Kootenay used bark canoes which were substantially different from the Interior Salish craft, and their cooking utensils were made of birch bark.

They were a happy, peaceful, and contented people, although few in number; only about a thousand of them were counted in the census taken in 1835. Over the next century their population dwindled, however, they maintained their cultural footing and have gradually regained their numbers.

When the Kootenay retreated from the Blackfoot and crossed the mountains into British Columbia and Idaho, they brought their horses, and to this day they remain accomplished horsemen. British Columbia is fortunate in having a small corner where a breath of the color and pageantry associated with the Plains Indians can continue to flourish in the land of the Kootenay people.

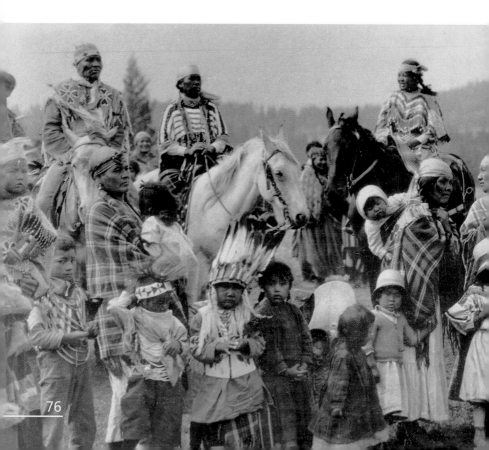

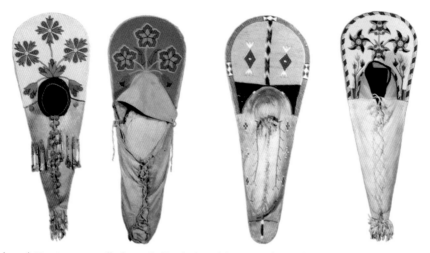

(above) Kootenay cradle boards (Butler). Babies were bound to special cradleboards, which were extremely portable. Babies could be carried on a woman's back, hung from the horn of a saddle or placed upright against the side of a teepee. Kootenay women would decorate the cradleboards with elaborate bead designs, hanging ornaments and charms on them for the baby to play with.

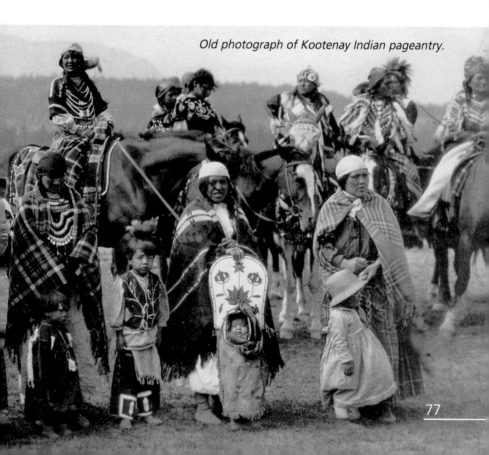

Old photograph of Kootenay Indian pageantry.

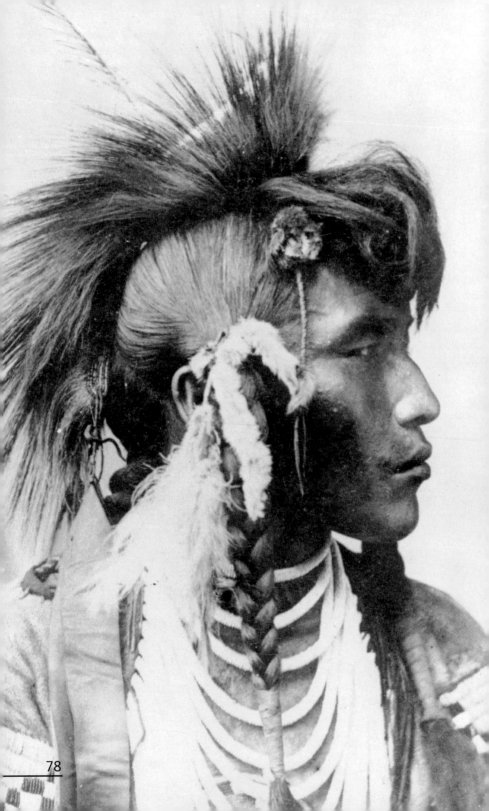

The Athapaskan Speaking Tribes

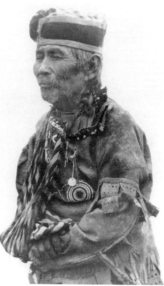

(right) Carrier Indian Chief at a Fort St. James pageant in 1928.
(Photo: Royal B.C. Museum)

Life for the Athapaskan speaking tribes of the central and northern areas of the British Columbian interior was harsh, especially during the long winter months, which in some of the northernmost regions lasted from September until April.

These were, of necessity, a semi-nomadic people, constantly in search of food and with little time or inclination for the cultural amenities enjoyed by the coastal tribes.

When we refer to the Athapaskan-speaking tribes of British Columbia — the Chilcotin, Carrier, Sekani, Tahltan, Beaver, Kaska, and Slave Indians — we must not lose sight of the fact that they were scattered and diverse, in no way united and, apart from similar dialects spoken by the tribes, felt little kinship with each other. Indeed they fought many skirmishes along their tribal borders.

Collectively, they numbered about 8,800 when the population census was taken in 1835; sixty years later their numbers had dwindled to 3,700 due to disease, alcohol, and in the case of the Sekani at least, starvation. But through the twentieth century the population, and their cultural pride and identity recovered to some extent.

CHILCOTIN

The Chilcotin are the southernmost of the Athapaskan tribes. They spread from the Cascade Mountains to near the Fraser River, and were known as a bold, restless, and turbulent people, constantly feuding with their Carrier kinsmen to the north.

Culturally, socially, and economically, they were much better off than their Athapaskan cousins. Surrounded as they were by the Salish tribes on their southern and eastern flanks, and by the Kwakiutl and Bella Coola to the West, they derived much of their social and material life from these neighboring peoples, at the same time clinging tenaciously to their own language and customs.

The Chilcotin traded heavily with their neighbors, particularly the Bella Coola, for salmon and the other necessities they lacked. This trade with surrounding tribes led to many other exchanges, resulting in the Chilcotin culture eventually becoming a blend of elements from different sources.

Food supplies were fairly plentiful. They hunted and trapped bears, wild goats and sheep, caribou, marmots, and rabbits, and gathered many varieties of edible roots and berries.

Their winter homes were rectangular, earth-covered lodges, walled and roofed with bark and brush. Some of them preferred to emulate the Shuswap and build small subterranean houses for use as winter dwellings.

Clothing was similar to that of other Athapaskan tribes — belt and breechcloth for men and skirts for women, leggings, and moccasins. During the cold weather they wore caps and robes of fur.

The Chilcotin women learned the art of basketry from the Shuswap, but the beautifully imbricated designs, which frequently included deer and other wild life, were uniquely their own.

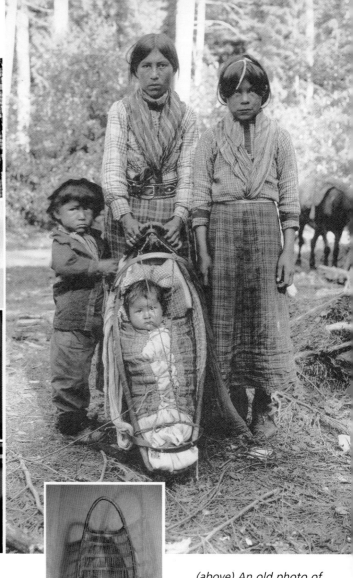

(above) An old photo of Chilcotin women and children. (Photo: National Museum of Man)

(above) Chilcotin baskets made of cedar root. The animal and line motifs woven into Chilcotin baskets are made from bulrush and cherry bark. These coiled baskets have willow loops beneath the rim to give them extra strength.

Frame of a Chilcotin cradleboard. Chilcotin women covered cradle frames with buckskin or cloth. Cradles would be carried by a strap that would be secured in place, across the back and over one shoulder.

CARRIER

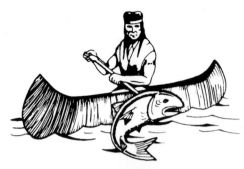

(below) An Athapaskan pouch.

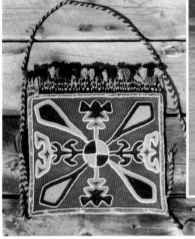

(above) Carrier Indians at Tachee Lake, B.C.
(Photo: Royal B.C. Museum)

The Carrier Indians were remote kinsmen of the Chilcotin and lived directly north of them. They roamed over the country of the Upper Fraser, Blackwater, Nechako, and Bulkley Rivers, as far north as Bear Lake.

The Carrier derived their name from the strange custom they had of compelling widows to carry the charred bones of their dead husbands on their backs, like bundles of firewood for a minimum period of two years. They were an austere and hardy people, greatly influenced in their social and political life by the Tsimshian, even to the point of copying Tsimshian noblemen in the practice of carving their crests on the pillars of their houses, yet lacking the artistic and creative ability of the coastal tribes.

Their staple diet was fish, since all the rivers fairly teemed with salmon during the summer months, and the lakes abounded with trout which could be caught under the ice during the winter. They also hunted bear, beaver, rabbits, marmots, and caribou and, like

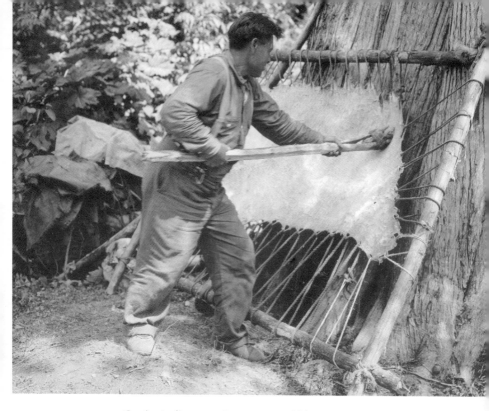

Carrier Indian scraping a moose hide. (Photo: National Museum Of Man)

most other tribes throughout British Columbia, gathered berries and roots whenever they were available.

They traded with the Tsimshian and other coastal tribes to obtain the coveted Chilkat blankets, copper bracelets, and shell ornaments. Yet they dressed much like the Chilcotin and other Athapaskan tribes, in skin robes, leggings, and moccasins.

Some of the southern Carrier passed the long winter months in underground lodges, similar to those of the Chilcotin and Shuswap. The remainder, however, preferred to build rectangular structures above ground, roofed with spruce bark, and gabled at the front and back by the continuation of the roof down to the ground on each side, thus omitting upright walls.

Warriors used the same weapons as the surrounding tribes — bows and arrows, lances, clubs, and knives. Hunting parties communicated with each other by making much use of graphic signs inscribed on rocks, which could be easily interpreted and understood.

SEKANI

North of the Carrier Indians, and frequently harassed by them, lived the Sekani — the people of the rocks. They controlled the basins of the Parsnip and Finlay Rivers, and the valleys of the Peace as far down as the present day town of Peace River.

Since supplies of fish were not plentiful, they became great hunters, living by the chase, and with no permanent villages. They lived mostly on moose, bear, porcupine, caribou, beaver, and any smaller game they could catch.

They erected rude conical lodges of poles, covered with spruce bark, or sometimes merely lean-tos, overlaid with bark, skins, or brush.

The men wore a kind of sleeveless shirt of skin, sometimes laced together between the legs in lieu of a breechcloth, leggings that reached to the thighs, and moccasins with insoles of ground hog, or rabbit fur. Women wore a similar costume, except that they either lengthened the shirt, or added a short apron, and their leggings only came as high as the knees. For winter warmth they wore robes, caps, and mittens. Hunters liked to adorn themselves with grizzly bear claws, and both men and women wore bracelets of horn and bone, while shirts and moccasins were often embroidered with porcupine quills.

The nomadic Sekani were blocked in their efforts to expand by the Cree and Beaver Indians on their eastern flank, and by the Carrier and Shuswap tribes to the south of them. Nevertheless, they traveled westward and occupied the territory around Bear Lake and the northern end of Takla Lake, and even managed to establish a village on the Tachick River, in close proximity to the Carrier of Stuart Lake.

This expansion took place around the end of the eighteenth century before the arrival of the early traders and trappers, which spelled doom for the unfortunate Sekani. Trappers and miners, bringing with them their alcohol and diseases, invaded Sekani territory and hunted their game, which soon became less plentiful. The tribe became demoralized, and undernourished, and rapidly decreasing in numbers, almost to the point of extinction.

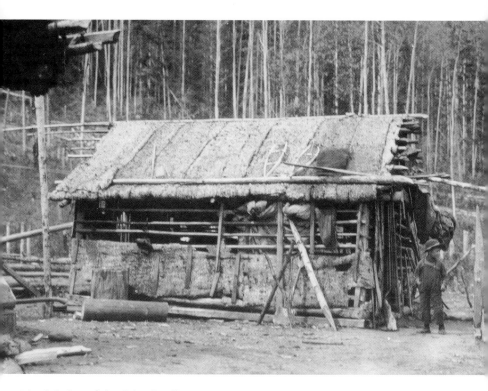

A bark lodge of the Sekani Indians. (Photo: National Museum of Man)

TAHLTAN

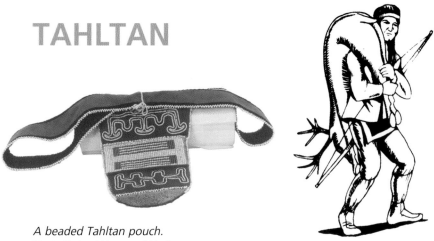

A beaded Tahltan pouch.
(Photo: National Museum of Man)

The Tahltan Indians were neighbors of the Sekani, yet were much closer to the Carrier in their dress and general mode of life. They occupied the extreme northern interior of British Columbia, including the country from the Cascade Mountains to the Cassiar River. This gave them control of the entire drainage basin of the upper Stikine River and the headwaters of some of the streams that fed the Taku, Nass, Skeena, MacKenzie, and Yukon Rivers.

Because of the dry climate and resulting light snowfall in winter, they were able to continue hunting the year round. But large timber was scarce, and the Tahltan were constantly forced to migrate in search of fuel.

The shortage of timber created other hardships for them. They were able to make only a few birch bark canoes, and these were of such poor quality that the temporary rafts they were forced to construct to ferry themselves across the numerous streams were almost as useful.

Their dwellings were simple lean-tos made of poles laid closely together, roofed with bark, and packed with earth and boughs around the bottom. Yet each of the six clans in the tribe owned a lodge for a permanent dwelling, one hundred feet or more in length, with vertical walls and a roof of bark. These large houses sheltered all the principal families of the clan and were useful as halls for potlatches and dances. They were located only in the Tahltan's principal village on the Tahltan River.

Tahltan sweat lodge at Casca Flats near Telegraph Creek.
(Photo: National Museum Of Man)

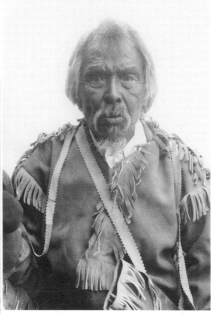

Tahltan hunter. The main hunting techniques employed by the Tahltan were use of snares and deadfalls. The Tahltan also favored spears, bows and arrows. (Photo: Department of Mines, Geological Survey, 1937)

The Stikine River valley, below Telegraph Creek, was shared by the Tahltan with the Tlingit, who caught salmon and gathered berries there during the summer months, whereas the Tahltan hunted over it during the winter after the Tlingit had returned to the coast.

Grassland and stony ridges covered much of the Tahltan country, yet it was rich in game and large shoals of salmon annually ascended the Stikine River. The Tahltan would scatter to the hunting grounds in early winter, then gather towards spring at the fishing grounds to await the arrival of the salmon. In the fall they assembled on the Stikine River to trade and barter with the Tlingit, and to enjoy the festivities that followed.

The Tahltan also traded with the Kaska Indians, exchanging moose and caribou hides, sinew thread, leather bags, and various furs for other items.

BEAVER

Until about the middle of the eighteenth century the Beaver occupied not only the entire basin of the Peace River below its junction with the Smoky River, but also the district around Lake Claire and the valley of the Athapaskan River as far south as the Clearwater and Methy portage.

In early times the customs of the Beaver Indians did not differ greatly from those of the Sekani. Around 1760, however, they were attacked by bands of Cree — who had been provided with firearms by the fur traders on Hudson Bay — and swept from the valley of the Athabaska and confined to the basin of the Peace. The eastern Beaver then made a truce with the Cree, consequently adopting their dress and many of their customs. They never attempted to regain their lost territories since the fur posts established soon afterwards took care of all their needs.

The western Beaver, moving further up the Peace River, managed to displace the Sekani from the mouth of the Smoky River to Rocky Mountain Canyon, and continued to maintain their old customs for several decades.

Like all of the Athapaskan people of northern Canada, the Beaver had no real unity and were divided into separate bands that roamed over separate hunting territories. Moose, caribou, beaver, and other game abounded, and there were numerous buffalo, which

the Indians drove into pounds, after the manner of the Plains tribes. Yet the Beaver appear to have esteemed the buffalo less highly than the moose, which gave them not only meat, but also skins for clothing and the covers of their tents. These tents were the conical, tepee-like structures common throughout the basin of the MacKenzie.

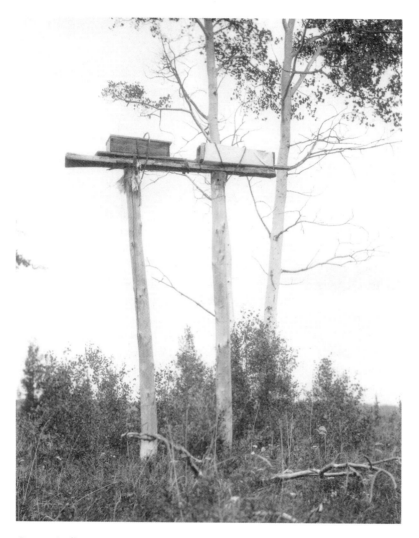

Beaver Indian graves at Fort St. John, B.C. (Photo: Mr. Narraway) *The dead were usually cremated or were placed high up in a tree.*

KASKA
(Kaska-Dene)

Athapaskan moccasins.

Little has been documented about the Nahanni Indians who once inhabited the mountainous area between the upper Liard River and the sixty-fourth parallel (according to anthropologist Diamond Jenness in his 1932 ethnographic survey "The Indians of Canada"). The Slave Indians massacred many Nahani and drove the remainder into the mountains. Originally they were divided into several independent bands, most of which have now disappeared altogether.

But from about McDame Creek on Dease River, to the Beaver River that joins the Liard River, lived two bands known as the Kaska Indians: the Tsezotene, Mountain People on the west, and the Titshotina, Big Water People on the east.

In their way of life, and indeed in most of their customs and religious beliefs, the Kaska differed little from the Sekani in the south, or from the tribes along the MacKenzie. Nevertheless, the geographical position of the Kaska near the headquarters of the Stikine River exposed them to influences coming from the Pacific Coast. They learned to weave the hair of the wild mountain goat into ropes, game bags, and even robes ornamented with beautiful blue and green designs. The Kaska lived principally by the chase, using bows and arrows, spears and clubs, and most especially snares of twisted sinew or babiche.

Like most of the northern tribes, the Kaska believed in a guardian spirit, acquired through dreams, to aid them in times of trouble. They copied the Tahltan and Tlingit in cremating their dead, but later abandoned this practice in favor of burial in the ground.

Athapaskan bow loom for weaving porcupine quills.

Babiche bag. Besides being used for ornamentation, babiche lines made of rawhide were strong enough to be used, to ensnare moose, beaver, or even grizzly bears.

SLAVE

Athapaskan gloves. The Slave Indians enjoyed highly decorated clothing.

According to the historical writings of Alexander Mackenzie, the Slave Indians were neighbors of the Beaver in the eighteenth century, and inhabited Athabaska Lake, Slave River, and the western half of Great Slave Lake. When the Cree Indians invaded this area the Slave were forced to retreat down the Mackenzie River, and by the end of the century occupied a broad stretch of country behind both banks of that river from its outlet at Great Slave Lake to Norman, the basin of the lower Liard River, and the west end of Great Slave Lake. They only occupied a small territory in the northeast corner of British Columbia.

The Slave Indians preferred to cling to the forests, and seldom ventured out onto the barren grounds. They used snares to trap all animals except the beaver, which they captured in wooden traps in the fall. Nearly half the diet of the Slave Indians consisted of fish, which they ingeniously caught in nets of twisted willow bark, or with lines of the same material fitted with hooks of wood, bone, or antler, and even occasionally bird's claws.

Their clothing was similar to that of the Beaver, but much more ornamental, with great use of porcupine quills and moose hair, and more heavily bordered with fringes. Moccasins were joined to the leggings and the men wore some sort of a tassel rather than a breechcloth. Around the mouth of the Liard River, where woodland caribou and moose were less plentiful, the majority of the women wore garments of woven hare-skin, a material that they also used for cradle bags.

Both sexes, with their great love of ornamentation, adorned

themselves with armbands of leather, embroidered with porcupine quills. Men added necklaces of polished caribou antler, and sometimes passed a goose quill or perhaps a plug of wood, through the septum of the nose. When on the warpath, the men wore headdresses of bear claws, or caps ringed with feathers, and protected their bodies with wooden shields and cuirasses of willow twigs.

The Slave used stone adzes shafted to wooden handles for cutting down trees, and knives with beaver-tooth blades for whittling wood and bone. For cooking, women used vessels of spruce roots, heated by means of hot stones.

It is said that surrounding tribes rarely ventured to attack the Slave Indians, fearing their great skill in witchcraft. Yet on the whole they had the reputation of being a peaceful, happy, and inoffensive people.

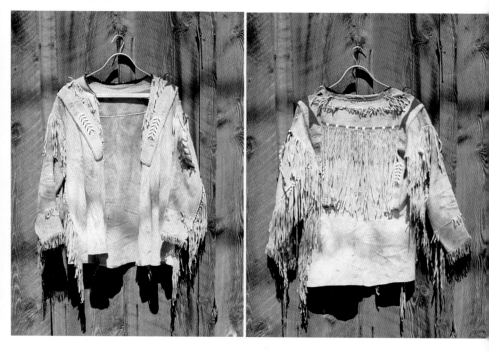

Athapaskan jacket. The Slave Indians' clothing was primarily made of Caribou skin, which was soft and quite warm. Men wore long tunics and breechcloths, while women wore knee length dresses. Both men and women wore leggings.

Nahanni Indian boys.
(Photo: Mr. Narraway)

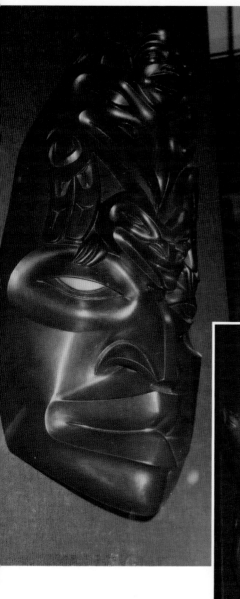

Contemporary Tahltan artist, Dempsey Bob, created these two bronze masks. The figures represented are Human (left) and Raven's Human and Frogs (below). Here the strong coastal elements of design and crest figures are incorporated for their saleability.

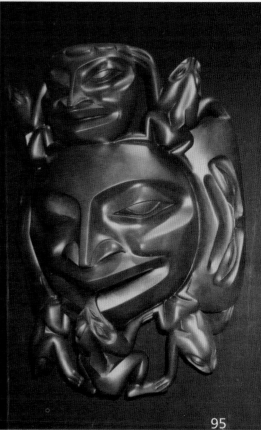